M000092032

BALTIMORE

✶ ✶ ✶

Baseball &

BARBECUE

WITH BOOG POWELL

STORIES FROM THE
ORIOLES' SMOKEY SLUGGER

ROB KASPER & BOOG POWELL

AMERICAN PALATE

Published by American Palate
A Division of The History Press
Charleston, SC 29403
www.historypress.net

First published 2014

Manufactured in the United States

ISBN 978.1.62619.578.3

Library of Congress CIP data applied for.

*To Jan and the kids. They have put up with all my idiosyncrasies.
It has not been an easy life, and they adjusted to make it happen.*
—*Boog Powell*

CONTENTS

ACKNOWLEDGEMENTS

When writing the story of someone's life, cooperation from his or her family is crucial. The Powell family has been most helpful in this project. Charlie and Richard Powell provided story after story about growing up with their brother, as did Carl Taylor, Boog's stepbrother and fellow major leaguer. Jean Terry, Boog's cousin, offered many details of the early life of the Powell boys in Lakeland and Key West.

Boog's son, J.W., and daughters, Jennifer and Jill, were forthcoming with tales about living with the man whom fans called "Boog" but they knew simply as dad. J.W. was also most helpful in plowing through files of family photographs in Key West, and Jan, Boog's wife, was adept at identifying the who, what and where attached to the old photographs.

Former Orioles teammates generously gave of their time to talk in interviews about their teammate. The Hall of Fame Robinsons, Brooks and Frank, offered long, warm and thoughtful recollections of playing with Boog, as did Jim Palmer, another Hall of Fame player. Andy Etchebarren, Merv Rettenmund and Eddie Fisher not only assessed Boog's baseball skills but also offered insights into his personality and his cooking.

Hugh Gallagher, the former ARA executive, told how he and Boog cooked up the idea of Boog's Camden Yards pit beef operation and how the concept spread to other ballparks throughout the nation.

Anyone who has visited Boog at his Camden Yards stand or his Key West home discovers that he has a large unofficial family. I met many of them. Thanks to Ann O'Brien, Wayne Dougherty, Randy McNeese, Jim

Halloran, Jack Hughes, Rod Rodriguez, Stan Charles, Jim Henneman and Bill Steka.

Much of the research for this book consisted of reading newspaper accounts of games gone by. The Baltimore County Library has an excellent online repository of Baltimore newspapers. Reading these accounts gave me a new appreciation of the daily work of former *Sun* and *Evening Sun* sportswriters such as Jim Elliott, Phil Jackman and Ken Nigro. The wry articles about Boog by current *Sun* sportswriter Mike Klingaman were a pleasure to read and quite helpful, as was a series of *Sun* articles by John Eisenberg on the 1966 Orioles.

Eisenberg's exceptionally readable book *From 33rd Street to Camden Yards: An Oral History of the Baltimore Orioles*, published in 2001, was helpful to me in capturing the history of the Orioles. Another useful book was *Ballpark: Camden Yards and the Building of an American Dream*, a 1993 work by author Peter Richmond. The staff of the Enoch Pratt Free Library, a city jewel, was adept at retrieving every book I sought, with one exception: Robert Whiting's *The Chrysanthemum and the Bat*, which went missing in the Pratt's stacks.

I also relied heavily on the Society for American Baseball Research (SABR), whose player profiles and trove of statistics are impressive. I joined the organization and encourage anyone interested in baseball history to do so. A benefit of being a SABR member is that it provided me access to the back issues of the *Sporting News*, another gold mine of baseball lore. Baseball-reference.com is an amazing tool, quick way to verify or as Casey Stengel said "you can look it up."

Paul McCardell, a librarian extraordinaire at the *Baltimore Sun*, helped me wade through the reams of newspaper photographs, and Zachary J. Dixon helped me secure the publishing rights to my picks.

Hannah Cassilly, my editor at The History Press, both encouraged me at the start of this project and helped bring it to fruition. Michael Cross-Barnet, my former colleague at the *Sun*, provided an eagle eye, tightening loose writing and correcting grammar and spelling. Any errors are mine. Photographer Jim Burger was a lifesaver. Whether the assignment involved traveling to the Eastern Shore, arranging a photo shoot at Camden Yards in frigid weather or electronically reviving old family photos, Jim was not only up to the task but also brought his winning and willing personality to each endeavor.

Members of my family—my sons Matthew and Michael and my daughters-in-law Crickett and Kim—tolerated listening to my endless Boog stories and appeared interested. They also were willing eaters when I tested some of Boog's recipes.

Finally, my wife, Judy, provided not only technical support—moving text through the sometimes murky waters of Word—but also emotional support, never doubting that despite the chaos in my office, this book would be written.

ROB KASPER

BOOG'S INTRODUCTION

Why am I doing this book? Well, I guess everybody feels his or her life is different. I feel my life is at least a little bit different because I was a professional baseball player who enjoyed cooking so much. So I teamed up with Rob Kasper, who for thirty-plus years wrote a lively food column for the *Baltimore Sun*, to tell my story.

There is plenty of baseball in my life and in this book. My time in the minors, the thrill of winning two World Series titles and a Most Valuable Player honor are covered here, as are the disappointments, such as losing the 1969 World Series to the New York Mets. Baseball was a big part of my life, but there were plenty other parts as well, including my family, my friends and my cooking.

When I think back about my seventy-plus years on this earth, I see a lot of the idiosyncrasies that made me who I am. As my former Oriole teammate Brooks Robinson, put it, I "live large." I also see a theme, an abiding interest in food.

I guess it all got started when I was a boy in Lakeland, Florida. Maybe it was the time my brother Charlie and I were "camping" behind our house and my dad, Red, brought us a rack of ribs and showed us how to cook them over an open fire. Or maybe it was the speckled perch I used to catch in Lake Hollingsworth that would serve as supper on days when the kitchen cupboard was empty. Fooling around with food became an integral part of my young life. Heck, when my brothers and I ran out of baseballs, we even used sour oranges from nearby trees for batting practice.

In baseball's minor leagues, I encountered new forms of weather—snow and ice—and I happened upon some gustatory delights. A landlady in Bluefield, West Virginia, introduced me to hard cider. In Rochester, New York, I roomed right next to a restaurant, Al's Garden Grill. Al fed me exotic omelets, convinced me that tomatoes for breakfast was a great idea and helped me court my wife, Jan. Our first date was at Al's Garden Grill. It was close, I lived right behind it and it was cheap.

When I landed in Baltimore as a rookie, Hoyt Wilhelm and a few other veteran Orioles players took pity on me and took me to Obrycki's in East Baltimore for steamed crabs. Man, were they something! I had already eaten the crab cakes at Burke's, one of the best things I had ever put in my mouth. After feasting on steamed crabs and crab cakes, I knew I was living in the right town.

A little later, while shagging fly balls in the outfield at Memorial Stadium, I caught a whiff of something delicious. It was pit beef that a caterer was grilling in the picnic area behind the outfield fence. I got a few fragrant slices passed to me through the gate in the fence, and I have been cooking pit beef ever since.

I had terrific teammates. We won some big games over the years—we were World Series champs in 1966 and 1970, and we were runners-up in 1969 and 1971. We also shared some good times. Frank Robinson presided over a clubhouse kangaroo court in 1966 and fined Charlie Lau and me for cleaning rockfish in the locker room showers. The fact that the fish were fresh (Charlie and I had caught them that afternoon in the Chesapeake Bay) did not dissuade Judge Robinson from fining us one dollar. In 1971, Brooks Robinson helped me carry a barrel of one-hundred-year-old sake into an elaborate ceremony in Hiroshima as the Orioles toured Japan. During one spring training session in Miami, I had to threaten Andy Etchebarren that I would toss him off a balcony if he did not man up and eat his first raw oysters. Andy still has not thanked me.

After games played in Baltimore, I often would cook in my backyard for a bunch of teammates. For a time, a lot of us—Brooks, Curt Blefary, Dave McNally and I—lived on or near Medford Road behind Memorial Stadium. Later, I moved to Towson, near Calvert Hall High School. I cooked there, too, and had some killer tomatoes, Better Boys, growing in my backyard. But I would cook late at night, well after the game was over. And the next morning, that Calvert Hall band would start practicing at seven in the morning and wake me up.

I cooked because I didn't want to go out to eat. When you are on the road for half of the season, you would just as soon stay home and cook a slab

of ribs. You can put your feet up. And all you have to worry about is your neighbor yelling at you to pipe down when you are cooking at two o'clock in the morning.

On the road, my roommates were often pitchers, and since pitchers work only every fourth day, they tend to stay out late on the road when they aren't scheduled to hurl. Being a good roommate, I often kept them company as we visited various dining establishments. In Boston, I discovered the stairway leading to a hideaway in the Durgin Park restaurant. Yogi Berra distracted me while I was batting by peppering me with questions about where I was eating. I struck out once while chatting with Yogi. The next time, I shut up and ripped a double. Yogi claimed he would never forgive me. In Kansas City, Moe Drabowsky almost got us arrested when he started a late-night craps game on the sidewalk after a visit to Dixieland Barbecue.

When I was traded to the Cleveland Indians, I kept cooking with teammates, albeit new ones. For instance, once, after a spring training session in Tucson, a bunch of Indians drove up to Mount Lemon. It was hot in Tucson, but up on the mountain, it was snowing. But it didn't matter as we tore into plates of grilled meat and washed it down with plenty of cold beverages. Then, in the dark, we inched our way down the twisting mountain road back to warmth and civilization. I finished my playing career in Los Angeles, a city where the fans took a liking to me and where I was introduced to the healing powers of menudo, a Mexican soup made with tripe.

After baseball, I had more time to cook. At a marina I bought in Key West, my family and friends fed crowds of boaters who came to town to compete in fishing tournaments. We dipped fillets of cobia in a spicy batter and fried them in sizzling oil. We cooked dozens of hams in a wooden box we dubbed the "Cuban microwave." We bathed chicken halves in a mojo sauce made of garlic and sour orange juice and then grilled them over an open fire. We made conch fritters but had to stop because we couldn't keep up with the demand. I no longer have the marina, but I still have those recipes.

I also secured a spot as one of the Miller Lite All-Stars, former athletes who chanted the "Tastes Great, Less Filling" virtues of the beer. I had many meals during those years traveling for Miller Lite. But none was more propitious than the lunch I had in New York with former umpire Jim Honochick. We had been filming a Miller commercial, and it wasn't going well. Jim was nervous. So when we broke for lunch, I told Jim we should have a martini or two. Well, we did, and Jim loosened up. We came back from lunch and shot that commercial, and the director said, "It can't get any better than that." In the commercial, Jim pretends he can't see me until

he puts on glasses and says, "Hey, you're Boog Powell." It turned out to be one of most popular Miller Lite commercials. People still come up to me in airports and say, "Hey, you're Boog Powell."

My work with Miller Lite and my experience cooking for crowds helped me land the job at Oriole Park at Camden Yards. The ballpark turned out to be a jewel, one that would be much imitated around the United States. So, too, was my ballpark pit beef stand. The concept of preparing food in the open, where customers could see the cooking, and having me, a former player, preside over the operation while greeting fans and signing autographs was new to Major League Baseball. But it soon caught on and spread to ballparks around the nation.

Now, during baseball season I am at Camden Yards for almost every Orioles home game. When the team is traveling, I often go crabbing in Chesapeake Bay with our son, J.W. He and I have our own way of cooking and serving steamed crabs. It involves apple cider vinegar and Old Bay.

J.W. is quite a cook. He runs a restaurant on the Ocean City boardwalk, Boog's Bar-B-Q. He is always giving me cooking shortcuts, such as making real biscuits with Southern Biscuit flour. All you do is add buttermilk, stir and bake. Our older daughter, Jennifer Powell Smith, is a mortgage broker who lives in Longwood, Florida. She still makes macaroni and cheese topped with tomatoes and pepperoni, one of the dishes her mother taught her. Jill, our youngest child, is in Pine Island, Florida. When she was a little girl, I would pull her on a towrope behind our boat as she dove down into the water and harvested conch. Jill is a realtor and makes a terrific conch salad, almost as good as mine. My wife, Jan, moves about in our winter home in Key West and our summer home in Grasonville, Maryland, with the help of a walker. Years ago, after a game, she used to cook one of my favorites— fried chicken livers with sherry. Now, on her birthday, I cook her favorite dish—grilled beef ribs served with spicy noodles.

I have had my share of injuries. Bud Dailey knocked me out with a fastball to the head in June 1962 and put me in the hospital for three days. When I was playing left field, I got my spikes caught in Detroit and tore a thigh muscle, putting me out of action for almost a week. While breaking up a double play, I collided with Yankee shortstop Tony Kubek, and his knee caught me in the chest, bruising and probably fracturing two ribs. That hurt.

The incident that frightened me the most, however, occurred not on the baseball field but in a doctor's office. During a routine physical exam in 1997, I discovered that I had colon cancer. It was troubling news because my good friend and former teammate Charlie Lau had died of colon cancer

in 1984 at the age of fifty. I reacted quickly. I met with the surgeon, Keith Lillemoe at Johns Hopkins, on Saturday, and he operated on Monday. I was in the hospital for a week and had an impressive string of visitors: Brooks, Frank, Palmer and sportswriter John Steadman. I took chemo for eighteen weeks. I hated it, but I haven't had any relapses. I had some heart trouble during the Christmas holidays in 2013 and am getting that treated.

We are not on this planet forever, and that is one of the reasons I wanted to do this book about my life and my cooking. I wanted to get it all down—or at least the most interesting parts.

I enjoy life and encourage you to do so. The recipes in this book could help increase that enjoyment. The stories I tell of what happened to me on and off the field might bring a smile. I swear on a stack of pit beef sandwiches that the stories are all true, mostly.

CHAPTER 1
EARLY YEARS

Contrary to his style later in life, John Wesley Powell arrived in the world as an average-size package. He weighed 7.5 pounds, about the national norm. At the time—August 17, 1941—his parents, Charles and Julia Mae Powell, had no inkling of the eventual size (six feet, four inches and 240 pounds) and national renown (American League MVP, four-time All-Star, winner of two World Series, national TV personality and Baltimore icon) their baby boy would attain. They were simply delighted that he had all his fingers and toes and that he had a healthy appetite, an attribute that would serve him well in later life.

There are two family stories on how the boy got his nickname. One is that he was a rascal and his dad, following a southern custom, called the boy a mischievous "booger," in time shortening it to "Boog." The other is that the moniker was bestowed on him by his aunt Eunice, who favored the lad and a radio show called *Dr. Boogit*. Whenever she visited the house, she would search out the boy by asking, "Where is that little Boogit?" Both stories probably have an element of truth. The certainty is that the nickname stuck.

Boog's father was a dashing young man whose shock of red hair earned him his own nickname: "Red." Red Powell was a boxer who eventually would log ninety fights and secure a state championship before returning to the ring, late in his career, as a referee. As a young man, he worked out in a gymnasium in the New Florida Hotel in Lakeland, Florida. Young ladies who had noticed him began to appear at the gym in the hopes of securing a date with the handsome redhead. One who succeeded was Frances Newbern

From an average-size baby to a beaming 1970 world champion. *Reprinted with permission of the Baltimore Sun Media Group. All rights reserved.*

Langford, a local girl whose golden voice and good looks would, in future years, land her singing roles with Bob Hope. In Lakeland, she and Red even appeared on a local radio station singing their trademark duet, "Stormy Weather." At the time, Red was also dating another local girl, Julia Mae Bryant. Julia Mae was tall, about six feet, with blonde hair and striking blue

eyes—features Boog would inherit. Her family, the Bryants, had deep roots in Florida, where their ranks included a former state senator and one-time members of the Confederate Cow Cavalry, a group Florida cattlemen who provided beef for Southern troops during the Civil War.

Not willing to take a back seat to any woman, Julia Mae told Red he had to marry her or say goodbye. He picked Julia Mae. Frances Langford went on to Hollywood, where she appeared in films and on national radio programs. She married three times, including to Ralph Evinrude, head of the outboard motor company.

The newly married Powells moved into a house on Ariana Street. It was near Dixieland school and backed up to empty lots filled with sand burrs, a site that would later be transformed into a baseball field. Red took a job selling used cars in a lot on Florida Avenue, and after Boog arrived, two more boys, Charles and Richard, entered the fold. In the evenings, for amusement, Red would play records, 78s of Tommy Dorsey and Benny Goodman, offering Boog a reward of a penny if the lad could correctly identify who was singing. Boog collected quite a few pennies.

There were also expeditions to a nearby farm run by Boog's aunt and uncle, Faith and Tom Harmon. It was there that a young Boog almost drowned, or at least put a serious scare into his mother. It happened when she was fishing in the farm's lake, a remnant of an old phosphate pit. She was using a cane pole, a bobber and a minnow or shiner for bait. She was, Boog would recall later, exceptionally patient. "One of my fondest memories of her was her ability to sit and look at that cork and wait for something to happen," he said. "She did it for the longest time."

Young Boog, who was then about five years old, was not so patient. He was sitting in a boat that was tethered to land and floating about ten yards off the shore and some fifty yards away from his mother.

"I was just sitting there," Boog recalled, "and it seemed like a good idea to jump in the water and swim to shore. Before I got to the shore, mother was there. She was panicked. Then she got me out and started laughing, and she held me and kissed me and dried me off. I went back to boat, but I never jumped in the water again.

"She went back over and sat down and started watching that cork. She caught a big bass, eight to ten pounds. It broke her pole, and she was hollering and grabbed a piece of the broken pole and dragged that bass onto the shore. I think she fried it up for us later that day."

Despite her strong spirit and good size, Julia Mae Powell was not in good health. A bout of rheumatic fever in her childhood had left her with a

weakened heart. One day, while playing ball with his mother in the backyard, Boog became painfully aware of her frailty.

"We were using a regular hardball, and I hit a line drive and hit her right in the stomach. She went down, and she couldn't catch her breath. Finally, she said, 'We'll do some more later,' and she went in the house. We never did it again. And I don't know if there was something that happened to her after that, but I kinda feel I might have had something to do with her passing."

For treatments, Julia Mae would go to the local hospital, where Boog and other family members visited her, seeing her shrouded in a tent filled with oxygen to ease her breathing. One Christmas, her last one with her family, she came home with the tent.

It was a holiday filled with bittersweet memories for Boog. "I got my first BB gun, a Red Ryder…that was mother's Christmas present to me. She knew how much I wanted it because everybody had one." But it was the final Christmas he would share with his mother. She died a short while later at the age of thirty-two. Boog was ten years old, his brother Charlie was seven and his brother Richard was sixteen months.

Julia Mae's mother, Ruth Bryant, known as Rucy, moved nearby to help raise the boys. In addition to the emotional hole left by the loss of their mother, household finances were tight.

Red did his best to keep the family together and put food on the table selling used cars. In flush times, when cars sold, there were ample groceries in the cupboards. Yet on days when cars didn't move off the lot, Red would phone home and tell his eldest son to go fishing.

"We knew without having to say anything that times were a little hard," Boog recalled of that period in his life. "We were a pretty tight-knit family. Even though we didn't have a whole lot, it didn't matter—we never went hungry."

After getting such a piscatorial request from his father, Boog would grab a rod—and a brother or two—and head for the water. There was plenty to be had in Lakeland, a community that took its name from the thirty-eight named lakes that dominate the local landscape. Residents of Lakeland tended to give directions by referring to bodies of water, not streets, as in, "I live near Lake Parker." The Powells lived near Lake Hollingsworth, but Boog had plenty of favorite fishing holes: Lake Wire, Crystal Lake and Lake Parker, as well as abandoned phosphate pits.

Boog's preferred catch was speckled perch, also known as crappie. But he was also on the prowl for catfish, bream and sunfish, known as shellcrackers. He would probe the waters looking for a hot spot. Once he found the fish (or

once it found his hook), the action was furious. No sooner had he landed one perch and tossed his hook back in the water than the line would go taught with a fresh strike. Soon he had a stringer filled with plump fish.

At home, Boog would clean the fish in the backyard, removing their heads, gutting them and then scaling them. Then his grandmother Rucy would roll them in cornmeal, fry them in hot lard and serve them with a pile of hot clabber biscuits, a flour biscuit that was made using milk that had has been allowed to sour or become "clabbered." It is also known as buttermilk and acts as a rising agent, making baked goods lighter and fluffier. A quart jar of clabbered milk was a staple in the Powell household.

"Those boys were big, and they were eaters," recalled Jean Terry, a cousin of the Powells who frequented the household.

"We would eat four chickens—thighs, breasts, gizzards and livers," Boog recalled. "My dad would sit there watching us and remark, 'I was thirteen before I knew a chicken had any part other than a back.'"

On school days, a local woman, Amy Brown, would come to the Powell home to care for the youngest boy, Richard. But on days when Amy couldn't make it, Boog would have to stay home and watch his little brother, an assignment he dreaded. "Richard was a load," Boog recalled. "You would turn around, and he would be five blocks away. He was a piece of work."

The domestic scene would change when Red remarried. Jayne Taylor came into the household with her eight-year-old son, Carl. The Powell boys pegged Carl as a "sissy" because he played the piano. Charlie, who was Carl's age, was especially rough on him, and the two tussled constantly. One epic battle occurred outside their house on July 27, 1953—the same day an armistice was declared in the Korean War.

Carl had Charlie pinned to the ground, and Charlie was issuing ugly threats of retaliation. A neighbor eyed the two and told them to stop because "the war was over." But the two combatants continued. Finally, Boog intervened, pulling Carl off Charlie and then preventing Charlie from charging Carl.

Boog was often the peacemaker, Carl Taylor recalled. "Boog took care of me...tried to keep Charlie off me. Boog had a kind heart." Charlie, he said, was a scrapper.

Eventually the family melded, and the boys, working with neighbors, banded together to transform the patch of ground behind their house into a makeshift ball field. The base paths were cleared of sand burrs, weeds with sharp, spiny thorns that thrived in the sandy soil. But the shallow part of the outfield remained thick with burrs, and so defenders played deep, positioning themselves on a patch of clay beyond the burrs.

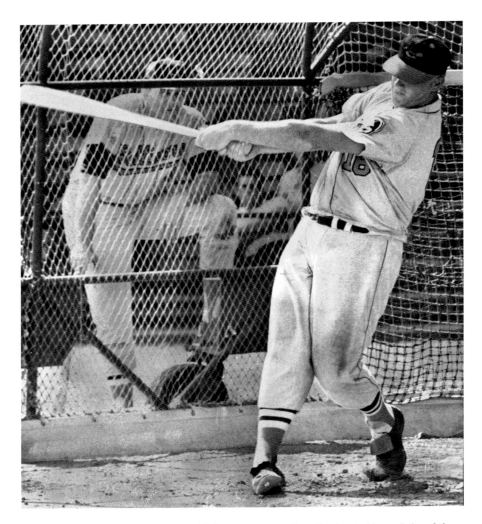

Boog's sweet swing was perfected by hitting oranges as a boy. *Reprinted with permission of the Baltimore Sun Media Group. All rights reserved.*

They couldn't play deep enough to catch Boog's towering shots, though. He would launch balls over their heads into distant thickets. The game would stop as the boys beat the bushes looking for the lost sphere, complaining all the time. "They would get mad at me and try to get me to look for the ball," Boog recalled. But he refused. "I told them, 'I'm not looking for the ball—I hit it.' Then they would find the ball, and I would hit it over their heads again. And the argument would start all over."

Good baseballs were at a premium. The Powell boys got some courtesy of the Detroit Tigers, who held spring training at Henley Field in Lakeland. Boog and his brothers climbed onto the roof of a building near the park's left-field foul line, a prime landing spot for wayward fly balls, and scooped up baseballs, some in good shape, some soggy. If, during a spring training session, a ball bounced out of the stadium, the Powell boys pounced.

Even so, there was a void some days, and determined to play some type of game, they substituted other orbs such as wadded-up socks, bottle caps and green oranges. "The smaller oranges were harder," Boog recalled. "They lasted more than one at-bat."

The Powells had tough feet; they were proud of the fact that they played baseball barefoot. This struck Carl Taylor, the newcomer to the family, as odd. "The sand burrs didn't stick to them," he said. "Not me; I had to wear shoes."

The nearby Dixieland schoolhouse also figured in their amusement. "We would play wall ball hour after hour," Taylor said. "If you hit a certain spot on the wall, it was home run; another spot was a double. If you caught the ball off the wall, it was an out. "

One day Boog's brother Charlie and a buddy from the neighborhood, Chuck Heddon, took their eyes off the wall and instead turned their attention to the windows of the school building. Arming themselves with the ever-plentiful Florida supply of green oranges, they had a gleeful afternoon seeing who could knock out more school windows. "Those windows didn't stand a chance," Charlie recalled years later. He also admitted the escapade was not too smart. The school custodian and his wife, head of the cafeteria, lived next to the building and saw the aerial assault. The fathers of the boys ended up paying for the replacement windows, and the boys were punished. "It did develop our arm strength," Charlie recalled.

The pre-adolescent boys roamed Lakeland, then a somewhat sleepy southern town known for its phosphate pits and numerous lakes, filling their days with what young boys did in the 1950s: playing ball, catching critters and wrestling.

Their bicycle, a heavy one-speed Schwinn with balloon tires, took them on adventures. A favorite bicycling ploy was to careen down a hill and plunge into Lake Hollingsworth. "Charlie would be on the handlebars, and I would be pedaling," Boog recalled. "We would get down to the bottom of the hill, and if there was a car coming on the road that went around the lake, we would put the bike, which didn't have brakes, in the bushes. If a car wasn't coming, there was a ramp leading to lake, and we would launch into

the water. Charlie would go flying one way, and I would go another with the bike. When I think about it now, we are lucky to be alive."

The bike also took them to games at distant ball fields. During one outing to John Cox Field on the other side of town, Boog's new baseball glove, a Wilson A2000, went missing.

"Back in those days, you used to leave your glove on the field and nobody would steal it," Boog recalled. "But somebody stole my new glove. I came home and had tears in my eyes. I had to tell Daddy. I knew getting the glove was a sacrifice for him because it had cost about twenty bucks, which we often did not have.

"But we got a phone call that night. A man talked to my dad and told him that my glove was going to be where I had left it. The man on the phone was a father who had seen the glove and knew his kid had stolen it. My name, 'Powell,' was on it, so he looked in the phone book and called us.

"We got in the car and drove over to the other side of town. And I walked out on the fields, and there it was. Oh man! You talk about being happy. I got my glove back. I never lost another glove."

Boog, his brother Charlie and his stepbrother, Carl Taylor, would go on to play on the epic 1954 Lakeland Little League team that won the state title, the South Regional Tournament and eventually advanced to the national championship in Williamsport, Pennsylvania. There, they lost to Schenectady, New York, the eventual champion. Boog was the losing pitcher in that game but had picked up a win a few days earlier.

In 1954, there were no rules limiting how many innings a boy could pitch. But there were many hurdles that anyone trying to move a Major League Baseball franchise from one city to another had to clear. A group of businessmen in Baltimore who wanted to move the St. Louis Browns to their city had cleared those hurdles, including winning the approval of Clark Griffith, owner of the nearby Washington Senators. Griffith had given his blessing after a Baltimore brewery, the National Brewing Company, had agreed to sponsor broadcasts of the Senators games and after a Baltimore beer man had given Griffith a birthday present of a silver bullet, the calling card of the Lone Ranger, star of Griffith's favorite television show.

The team now called the Orioles received a jubilant welcome when it paraded through downtown Baltimore in 1954. The losing hurler on the Lakeland Little League team would join the Orioles seven years later and begin a long, warm relationship with the town.

Reflecting on their early days, the Powell brothers and Taylor recall playing in seemingly endless pickup games. All the boys could hit. Once, on

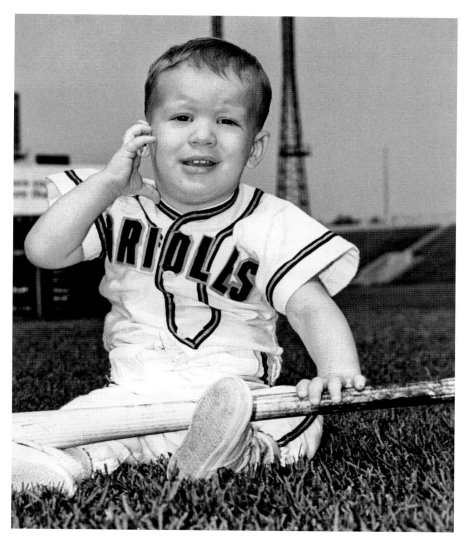

Boog's infant son, J.W, with his dad's bat at Memorial Stadium. *Reprinted with permission of the Baltimore Sun Media Group. All rights reserved.*

a bet, Richard hit a softball out of a ballpark while swinging the bat upside down, with the fat part of the bat in his hands and the handle over the plate. Taylor made it to the major leagues and played for six years with the Pirates, the Cardinals and the Royals before finishing up his career pitching batting practice for the Yankees. Charlie played minor-league baseball for several

years before an injury forced him out of the game. Their wall ball games in the schoolyard trained their reflexes and resembled the games of pepper played by major leaguers, Taylor said.

In addition to drills, a passion for the game grew in their hearts. Boog developed what he would call "an insatiable urge" to play baseball.

At night, after the local recreation league had finished play on the nearby Dixieland fields, young Boog Powell would make his way onto a darkened diamond and run the bases. "I would imagine myself playing," he said. "I would steal second with a fadeaway slide. I would dive into third. I would do a hook slide away from the catcher's tag, barely putting my foot on the base. Then I would get up and do it again."

He would come home filthy, wash himself off with the garden hose, climb into bed and dream of one day playing in big leagues. That dream would come true, but first he would have to negotiate moving to a new city and attending a new high school, as well as the journey through the maze of the minor leagues.

CHAPTER 2
A TEENAGE SLUGGER

As Sandy Koufax and the rest of the 1966 Los Angeles Dodgers would learn, Boog Powell had a knack for driving the ball. In that World Series, he batted .357, the best average among the Orioles. The boys of Baltimore beat the touted Dodgers in four straight games to capture baseball's biggest prize and give the city its first World Series crown.

Yet when this slugger was a teenager, he had trouble getting picked for teams that played in a Sunday recreational league in Key West. Boog was the new kid in town. His father, Red, and Red's new wife, Jayne, had moved their family of four boys almost four hundred miles south, from Lakeland to Key West. Red Powell, who had sold used cars for Bevis-Lewis Chevrolet in Lakeland, continued his trade for the same dealership at its Key West location. Sitting in the Florida Straits a mere ninety miles or so from Cuba, Key West is the southernmost point of the United States. It was also a tight-knit town, as Boog, then about fifteen years old, would discover. Sunday after Sunday, hoping to get on a team, he would carry his glove, spikes and bat to Wickers Stadium, a park that once played host to minor-league teams.

He was tall, skinny and talked with a country accent. Sunday after Sunday, he was disappointed, as no team would choose the new kid; they had no idea he was a veteran of the Little League national championships. Then, one Sunday, one of the regular players on the team sponsored by KT Volkswagen failed to show up, and Boog got his chance. He was told to play right field and given the ninth and last spot in the batting order, an assignment usually

Boog visiting his dad, Red Powell (long-sleeved white shirt next to Boog), with (from left) pitchers Don Larsen and Gene Brabender; M.P. Tomlinson, for whom Red worked; and an unidentified car salesman at Tomlinson's car dealership. *Author's collection.*

given to the team's weakest player. His youngest brother, Richard, then about eight years old, watched the proceedings from the stands.

"The first time up, Boog hit a screaming line drive past the first baseman," Richard Powell recalled. "That kinda got their attention. Then the next time up, Boog hit one over the fence, over a parking lot, across the street and into senior citizen housing. It probably went four hundred feet, and for a kid of fifteen or sixteen, that was unheard of. The next Sunday, there were three cars waiting at our house to take him to the ballpark."

"They were fighting over me," Boog recalled. "The KT Volkswagen team and the one sponsored by Jon's Deli kept saying, 'I saw him first.'" Boog ended up playing with KT Volkswagen.

After this auspicious beginning, word of the athletic prowess of Boog and his brothers soon spread around Key West. Boog would star in three sports—baseball, basketball and football—for the Fighting Conchs of Key West High School. He was all-state in all three. His brother Charlie and his stepbrother, Carl Taylor, were on the high school baseball team with

him that vied for the Florida state title. The youngest, Richard, went on to be become the Florida state high school champion in the discus throw and garner All-American honors at Manatee Junior College in Bradenton.

Their dad rarely missed watching a game in which his sons played. "Nobody could step on the toes of Red Powell's boys," Jean Terry, a cousin, recalls.

Another strong character in their boyhood was Ben Howell, known to the family as "Uncle Ben" even though he was, in fact, a distant cousin. Later in his life, Howell would sell cars in Key West with Red Powell, but in his early years, he was a forest ranger. He was a masterful hunter and fisherman who befriended the Powells and taught the boys about nature and outdoor cooking.

Howell had gone pheasant hunting in Romulus, Michigan, with Yankee slugger Lou Gehrig, an experience he would reminisce about with Cal Ripken Jr. in the Oriole clubhouse on the night in September 1995 when Ripken broke Gehrig's record for consecutive games played.

"Ben asked me if there was any way he could meet with Cal because he had this connection to Gehrig," Boog said, recounting the night Ripken broke the record of 2,131 games. "I said I didn't know. So I went down to the clubhouse and found Cal, and Cal said, 'Hell yes, I need a break. They [members of the media] are driving me nuts.' So we went back in to equipment manager Jimmy Tyler's room and sat there for fifteen minutes, and Cal talked with Ben, who told him all the stuff he knew about Gehrig. Ben was telling him how they used to hunt together and how when the Yankees were in Detroit, Gehrig would get him tickets and they would go out to dinner afterwards. It was heartwarming…one of the classiest things anyone has ever done, and Cal was a part of that."

Howell was a legendary marksman. "I saw him shoot a snake between the eyes when it was twenty yards away moving through the brush," Richard Powell recalled. "And I saw him put a [fishing] plug on a lily pad twenty yards away, into the wind."

He brought another gift to the Powell boys: humor. "Ben would tell us joke after joke," Boog recalled. "The more he talked, the more we laughed. Ours was not a sad house."

Once again, these outdoor skills came in handy to the Powells. "When we didn't have meat, we would go fishing," Richard remembers. "We would have fish for supper, or we would just eat beans. It is a good thing nobody ever came around and told me I was poor because I never would have known. We had everything; we just didn't have a lot of anything."

There were oysters aplenty in the waters of Florida, and Boog dad's was adept at catching and cooking them. "He would go oystering, come home and start a fire in the yard," Boog recalled. Then, when the fire died down to coals, he would get a piece of tin as big as a table, put it over the fire and lay those oysters on top of it. As soon as those oysters popped open, we would eat them."

Avid outdoorsmen, the Powells ate plenty of creatures with fins or fur. A favorite of Boog's was fried squirrel with gravy and fresh biscuits. He had a taste for turtle, back in the days when catching sea turtles was legal. Chicken feet, chittlerlings and tripe were also on his menu, but during a visit to his grandmother, young Boog was put off by one victual: fish eyeballs: "We were visiting my dad's mother, Bessie Powell, and she had fried up a mess of bream [sunfish]. She left the heads on the fish. Then she reached over, poked out one of this eyeballs and ate it. She told me, 'If you ever get a fish with blue eyeballs, those are the best.'" She asked Boog if wanted to try an eyeball, and he shook his head "no." And to this day, he has not eaten an eyeball, blue or otherwise.

Boog looked forward to road trips to Miami with the high school baseball team because it gave him a chance to enjoy a rare treat: steak. "I don't remember having a steak until I was about sixteen years old. Daddy came home and put a pile of charcoal outside, and he propped up an old refrigerator grate and cooked on it," he recalls. "But on high school road trips, we had steak. On the way to play a team in Miami, we would stop at Holsum's restaurant, and the whole team would get steak. I would get the fat, the burned crisp part, from all the guys who didn't want it. I would say, 'Man, why are you throwing that away? I would sit there and eat the fat, and they go, 'Ugh!' Man, I loved it."

As his high school career came to a close, Boog was widely recruited by college coaches. Noting that he averaged seventeen points a game as center on the high school basketball team, representatives from the University of Mississippi offered him a scholarship to play basketball there. But Boog was suspicious. "I think what they really wanted to do was get me to Mississippi and then work me into playing football," he said. He had played offensive and defensive tackle in high school, and almost every recruiter mentioned how nice it would be to put him in the football uniform of their school. On a recruiting visit to the Naval Academy in Annapolis, he was put in a submarine and allowed to shoot a mock air torpedo at a navy ship. Pretending to be a torpedo sharpshooter was appealing to Boog, but the disciplined lifestyle of the Naval Academy was not.

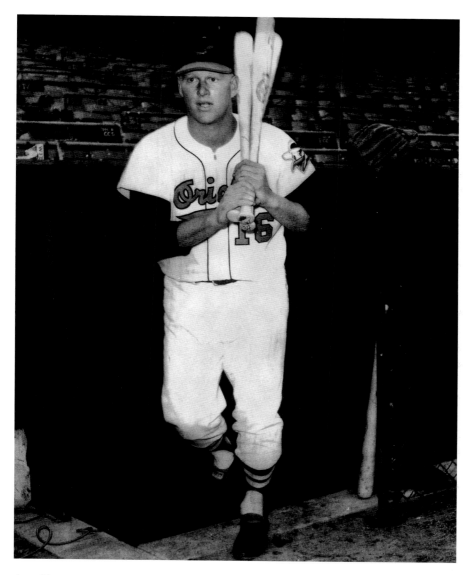

A rookie carrying big bats during spring training, 1962. *Author's collection.*

Meanwhile, football coaches from colleges around the South paid visits to the Powells' Key West home at 2932 Harris Avenue. One afternoon, a large, dark limo pulled up in front of the house, and out stepped Alabama coach Paul "Bear" Bryant. "Son," Bryant said, "I would like you to play football

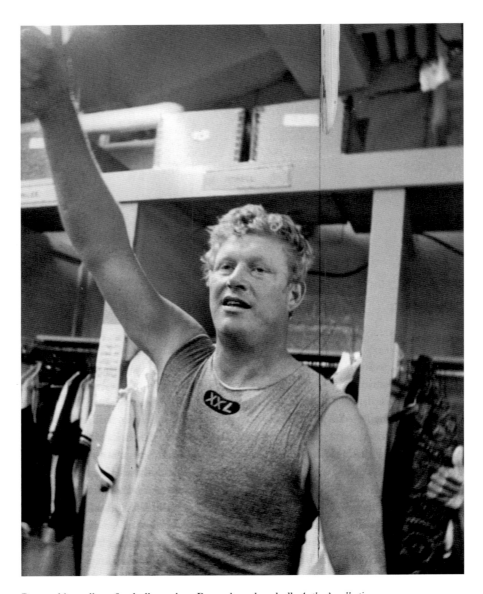

Pursued by college football coaches, Boog chose baseball. *Author's collection.*

for Alabama." Boog shook the coach's hand and replied, "I will certainly consider it."

He was also sought after by Florida State coach Tom Nugent, who told Boog he would play fullback in the team's new I formation. Nugent later

went on to coach at the University of Maryland. Boog surmised that being fullback in the I formation meant he would do a lot of blocking and not much running, and that did not sound like a job he wanted.

He came close to playing football for the University of Florida Gators, even signing a letter of intent. He was "a gator at heart" but in the end decided to cast his lot with baseball.

A scout for the Orioles, Freddie "Boot Nose" Hoffman, who got his nickname when his nose was broken during his years as a catcher for the New York Yankees, had been trying to sign Boog as a Bird.

In the spring of 1959, some thirty-eight big-league scouts and officials had gathered at the Florida high school tournament in Fort Pierce. Boog had a weak showing in the tournament, and many of the scouts lost interest in signing the young prospect, leaving only the St. Louis Cardinals and the Orioles in the quest. One story from a former Orioles scout says that to avoid a bidding war, representatives of the two teams agreed to flip a coin, with the eventual winner (the Orioles) getting the right to negotiate with Boog and his dad.

Boog discounts the coin-flip story, saying the team he aspired to play for was the Detroit Tigers. The Tigers held spring training in Lakeland, and Boog and his brothers had prowled around the old Henley Field Ball Park searching for stray baseballs. Moreover, a couple of the Tigers, including outfielder Johnny Groth, had rented rooms during spring training from Boog's grandmother Rucy and would toss an occasional baseball to the Powell boys.

The Tigers, however, were not interested in Boog, and after an all-night negotiation session, Boog and his dad agreed to terms with the Orioles.

"It was a $20,000 signing bonus, paid out over three years," Boog recalled. "About half was taken in taxes, but I was making $480 a month and never needed anything."

A long career of better days and big meals lay ahead.

CHAPTER 3
THE MINORS

Two days out of high school, a lanky Boog Powell began his trek through the minor leagues of baseball. It would be a bumpy three seasons. He would meet disappointment, but he would also meet Jan Swinton, the young woman from Rochester who would become his wife of fifty-plus years and the mother of his son and daughters. He would taste his first Baltimore crab cake at Burke's restaurant and, at the same time, get a taste of big-city crime. He would listen to advice from his coaches, some of it good (like how to hit a curve ball), some of it bad (like telling him he should choke up and become a singles hitter). He would roll across the country in a series of snappy-looking convertibles with laughing teammates and a portable record player sharing the back seat. He would encounter the ugly reality of racial prejudice and the splendor of the northern lights. He would rub elbows and sometimes egos with Paul Richards and Earl Weaver. He would get a bat—a big, heavy one—from Cal Ripken Sr. This cudgel would serve him well.

Boog was seventeen and anxious when he arrived at his initial stop in the minor leagues: Bluefield, West Virginia. It was the first time he had been on an airplane, and the propeller-driven planes—DC-3s and DC-6s—had made several stops on the journey from Miami. The last stop was harrowing.

He flew into Charleston, West Virginia, where the airfield was carved out of the top of a mountain—a piece of geography that made Boog, a boy from the marshes and flatlands of Florida, quite uncomfortable. As the plane rolled to stop and turned to head to the terminal, Boog looked out the window and saw a steep drop at the end of the runway. He surmised

Cal Ripken Sr. persuaded Boog to use a big bat, but not this one. *Author's collection.*

that if the plane had not stopped when it did, "we could have rolled off that sucker." The swamps of Florida seemed far away.

He got another scare—facing a big-time fastball—when he first stepped into the batter's box in Bluefield. He faced a young hurler from Wayne, Ohio, named Dean Chance. Chance would later go on to record over 1,500 strikeouts in eleven years in the big leagues, and Boog was an early victim of the fireballer. "Dean Chance and those guys were throwing a hundred [miles per hour] back in those days," Boog recalled. "At first they were throwing fastballs by me. And I was thinking, 'What have I got myself into? What a dumbass—how could I do this?'"

Tempted as he was to go back to Florida, he instead stayed in Bluefield and repeatedly went back in the batter's box and took his swings. His persistence paid off. "After about a week, I started catching up to those boys," he said. "I had to click the dial over to about nine, and I started catching up them. I had a real good year in that rookie league. I hit something like .350 and had fourteen home runs in about sixty games."

Boog and two other young ballplayers, Bobby Saverine and Buster Narum (both of whom would later play for the Orioles) rented rooms in a Bluefield home. There, they became acquainted with the pleasures of drinking hard cider, a beverage that was introduced to them by their landlady, a woman in her eighties. "One day we came home from the ballpark," Boog said, "and she said, 'I want you boys to help me celebrate today, for this is my birthday.' She handed me a shovel, and she said, 'I want you go to the front of the garage on the left hand side and dig down. Be very careful, and down about two feet you will feel something.'"

Boog did as he was told, and he unearthed a jug of hard cider. "It was probably twenty years old, in perfect condition," he added. There were several possible explanations of why the jug was buried. Cold ground would keep the cider in fine form. In cider-loving circles, it was a tradition to bury a jug, usually an empty one, under a new building for good luck. Or, in keeping with the community's religious norms, the landlady might not have wanted to keep alcohol in her house and instead hid it in the backyard.

Young Boog did not question why the jug was buried, but he did enjoy its contents. He presented the treasure to his landlady, who announced, "Boys, I want you to help me drink this." The young ballplayers complied with her wishes. "It was sharp," Boog recalled of the cider, adding that is about all he remembers of that cider-sipping night.

Late in the season, Boog sprained his ankle sliding into third base, and he was sent over to Baltimore from Bluefield to have the team doctor, Edmond McDonnell, examine the injury. The prognosis was that the injury was not serious, and he was told to just rest the ankle.

While in the city, Boog explored its delights. "I was staying at the Southern Hotel, right across Light Street from Burke's restaurant." He had heard of the delectable dish, the crab cake, and prepared to sample his first. The experience turned out to be bittersweet.

"I had my high school class ring, and I put it in the dresser drawer in the hotel and went across the street to Burke's to have a crab cake because everybody said that was what you had to have." The crab cake was so good, he ordered a second. "It was," he recalled, "one of the greatest things I had ever tasted." But when he returned to his hotel room, the ring was gone. Someone had stolen it. "That," Boog says decades later, "was a seventeen-year-old for you."

Baseball is called the summer game, but when you are breaking into it, you play it in the winter as well, in the instructional leagues. That winter, Boog played in an instructional league in Clearwater, Florida. One of

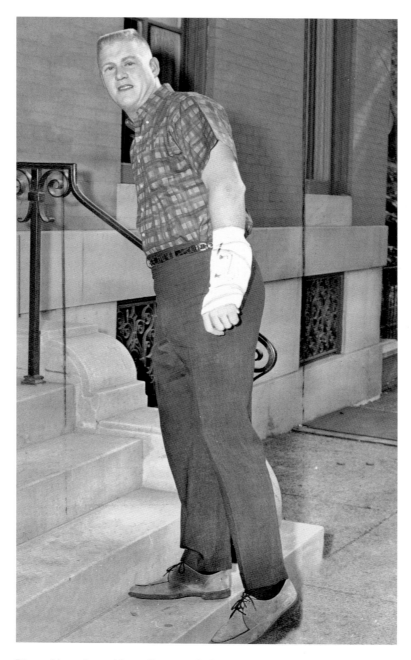

Plagued by wrist problems, Boog regularly climbed the white steps of the downtown offices of Baltimore doctors. *Reprinted with permission of the Baltimore Sun Media Group. All rights reserved.*

the coaches there, Eddie Robinson, worked with him teaching him the intricacies of playing first base. "He taught me how to step behind the bag, how to take throws and what play was important in certain situations," Boog recalled.

Robinson stressed blocking the ball. "You never let a ball get by you, no matter what," Boog recalled. "It was pretty hard to get something by me; most of time I kept it out in front."

Boog also got some advice (which he eventually discarded) suggesting that he punch the ball into the opposite field rather than try to drive it deep into the power alleys of right and left center.

"I had one instructor, Al Vincent, who said to me, 'Son, you are never going to hit the way you are hitting now.' He said, 'I want you take this forty-ounce bat, choke up and hit the ball into left field.' I did that, and he said, 'See how easy that is.' And I said, 'Yes, Mr. Vincent—but I don't like this.'"

The coach replied that Boog would probably never make it to the big leagues unless he changed his batting approach. Boog was undaunted. "I said, 'Well, I will just have to take my chances.' I was a pretty confident young man. You have to be. To be a .300 hitter, you fail seven out of ten times. You have to be confident about something."

As a kid in Little League, Boog was a switch-hitter. Playing with his brothers, he would swat rocks, oranges and baseballs both right handed and left handed. But as a teenager, swinging from the left side of plate began to "feel naturally comfortable," and he stayed there.

After completing the instructional league, Boog was ready in March for spring training with the Orioles. There, he came under the tutelage of Orioles manager Paul Richards. "Paul worked me really hard in spring training," Boog recalled. "Every time I did something, he was right there watching."

Orioles coaches put Boog and fellow first baseman Bob Boyd through vigorous workouts, called both "shin burners" and "shin burgers," to improve defensive skills. "After everybody else was done for the day, a coach would take us down the right field line and set up a pitching machine, an Iron Mike, with it aimed at the dirt," Boog recalled. "He would load it up with fifty balls, and we would take fifty balls in the dirt, right up against the right-field wall. We would take fifty, and if he wasn't happy, we would take fifty more. More than one day I took one hundred of those shin burners. I had good hands, and he really worked me hard."

Boog was not going to the big leagues just yet. Instead, he was going to Appleton, Wisconsin, to play on the Fox City Foxes, a minor-league team in the Orioles organization managed by a second baseman named Earl Weaver.

Before Boog reported to Appleton, the Orioles skipper, Richards, encouraged him to take a week off. At first, Boog thought this was a good idea. He drove down to Key West to see his family. But he quickly became uneasy. "I got home and I said to myself, 'What are you doing? You are a ballplayer.' So I had dinner with my family, and I said, 'I'll see you later' and jumped back in the car—I had a 1960 powder-blue Chevrolet Impala convertible with a white top—and took off for Thomasville, Georgia, where the Orioles were still in spring training. Thomasville was an old army camp. The players, all the lower-level Orioles minor leaguers, were there. I think I was number 560 in camp—that was the number on my back."

Boog slept in barracks, and his days were run with military-style rigor. "You got up at reveille every morning, you had breakfast and you jogged to the field, about a mile away," Boog recalled. "At noon, buses would take us back to the barracks for lunch. After lunch, we would walk back to the field, down a dirt road. We worked until three or four o'clock in the afternoon. Then, buses would take us back to the barracks. You would get showered up, and then there wasn't anything to do."

It was here in this rural setting that the stress on fundamentals known as the "Oriole Way" was born. In his book *From 33rd Street to Camden Yards: An Oral History of the Baltimore Orioles*, former *Baltimore Sun* sports columnist John Eisenberg states that "it all started in Thomasville."

A later visitor to Thomasville who was struck by its singular focus was a young pitcher named Jim Palmer. "It was the perfect environment to focus on baseball, which was what you were trying to do because the more you could do that, the sooner you got to the big leagues," Palmer, a Hall of Fame pitcher, told Eisenberg. "I had no money, no nothing, nothing to do. The facilities were horrible. Two ping-pong tables. If you lost, you waited for two hours. It was the perfect environment to focus on the game. I don't think they even had a TV. I just sat around the barracks and listened to George Bamberger tell stories about pitching. It was probably one of the better things that ever happened to me."

When camp ended, Boog and the other minor-league players were left to their own devices to find their way to their respective teams. Boog pointed his powder-blue convertible north and, along with fireballer Dean Chance and George Stepanovich, a big pitcher who had played basketball at North Carolina State, took to the road.

"George was from Chicago, and when we got there, George promised, 'Boys, I am going to show you stuff in Chicago you have never seen before.'

Man, did we have a good time. George took us on a tour of what we shall say were interesting lounges," Boog recalled.

When the trio eventually arrived in Appleton, Wisconsin, they got a chilly reception. Boog, a Florida kid, looked up and saw this strange white material falling from the sky. It was snow, and it was the first time he had ever played baseball in it. He was not thrilled. "It was snowing in April; the field was mud and slush," he recalled. "It was thirty-four degrees on Opening Day. Again, I was thinking, 'What have I got myself into?'"

The team, the Foxes, started off slowly but soon hit its stride. Seven players from the Class B team ended up in the big leagues. Cal Ripken Sr. was the catcher, and Earl Weaver was the player/manager—until one day in Des Moines. That is when his career as a second basemen ended.

"One day, Earl jumped up to catch a line drive, and it him in the chest— right in the sternum. He is laying there, and we are laughing our rear ends off," Boog recalled. "We were waving our hats over him. Earl is just saying, 'I quit. I quit.' That is when he quit playing and was just managing.

"Earl was an innovative manager even then. We had these trick plays, plays that worked in the big leagues, too. One was when you had runners on first and third and a left-handed pitcher on the mound. The runner would break, with the runner on first taking off a bit sooner. The pitcher would throw to first, and we would get a run out of it. But once word got out about that play, all you would hear from the other teams was, 'Watch out for that play…they got that play.'"

It was in Appleton that young Boog discovered the pleasures of the flesh and the beauty of the northern lights. They occurred simultaneously. One night, swimming nude in a local lake, Boog and a young lady were engaged in intimacies when the skies erupted in flashes of red, green, blue and violet light. It was the aurora borealis. "Wow," Boog thought, "sex is always going to be like this."

The Fox City Foxes did well, winning the league championship. Following the advice of the team's catcher, Cal Ripken Sr., Boog switched to a heavier bat.

"Cal Sr. swung a 36-36 (36 inches long, 36 ounces), which is a man-size bat," Boog recalls. "Senior was not big—I bet he didn't weigh 170 pounds. But he was way strong. You would never want to mess with him. He knew I was swinging a Mel Ott 0-16 bat, but it weighed 34 ounces. He talked me into going to 36 ounces, and I swung that bat, 35 inches by 36 ounces, pretty much the rest of my career."

After the summer season ended, many of the Appleton team members, including Boog, made their way to Scottsdale, Arizona, for winter instructional league.

Earl Weaver (center), Boog and pitcher Dick Hall, circa 1969. *Author's collection.*

Boog's drive out to Scottsdale was eventful. In the middle of Texas, his new ride, a 1960 Oldsmobile 98 convertible, overheated. "I ended up walking down a country road in the middle of nowhere," Boog recalled. "I found a family and told them my car overheated and that I needed some water. This fella just sat on his porch, lifted up his finger and said, in a deep Texas twang, 'The pump is over thar.'"

Boog limped into Orange, Texas, where his convertible got a new eighty-dollar thermostat at the Oldsmobile dealer. "That was a lot of money in 1960," he remarked. "I think they saw me coming."

During his drive back to Florida from Scottsdale, he encountered a different kind of trouble: racism. Two players, Nielsen (Nellie) Cochran and Lionel Rodgers, had agreed to chip in for gas and ride with Boog back east. Cochran would be dropped off in Jackson, Mississippi, a state that would later send his brother, Thad, to the United States Senate. Rodgers was headed for Miami, where he would fly to Nassau, in the Bahamas, where his brother and future Chicago Cub shortstop Andre also resided. Lionel had hit .345 to lead the Winter Instructional League in Arizona.

But when the trio of ballplayers tried to enter a restaurant in New Mexico, they were turned away because Rodgers was black.

When he was growing up, Boog's interactions with African Americans had been personal, not political. In Lakeland, he and his brothers had been cared for by an African American woman, Amy Brown, whom the family hired after the death of the boys' mother. In Key West, he, like most American kids of that era, had attended a segregated high school. Even though his all-white Key West High School football team never formally played the team from the town's all-black high school, Douglas, boys from the two schools gathered for informal tackle games on Sunday afternoons at a rocky Key West field known as the Naval Annex.

"They were some really good football games—they were not touch," Boog said. "I used to get a chance to carry the ball in those games, and they used to call me 'Colossal Man.' The guys from Douglas would say, 'Look out for Colossal Man, he'll run over you.' I still hear that 'Colossal Man' in Key West to this day."

"I grew up in a community that was segregated," Boog recalls, "but I never seemed to pay much attention to it." But that day in New Mexico, racial segregation drew his attention and his anger. "It was the first I ever realized that Lionel couldn't go into the same restaurant with us. That was ugly, and it really pissed me off. Lionel said he was used to it. But I wasn't. So from then on, we ate baloney sandwiches in the car. Two days later, we got to Jackson, and Nellie's parents welcomed us with open arms. The next day, Lionel and I left, and I dropped him off at the airport in Miami and went on to Key West. Then I read that Lionel was killed in a car wreck in the Bahamas."

Months later, spring training began, and Boog's dad drove him from Key West to the Orioles' camp in Miami. As the Powells emerged from their car, the first player they bumped into was Brooks Robinson, then a five-year Oriole veteran. "Don't worry, Mr. Powell, I'll take care of him," Brooks told Boog's father. "I needed to be taken care of," Boog recalled years later. Another veteran who took Boog under his wing was Gus Triandos. The big catcher cast a disdainful glance at Boog's baseball shoes, a pair of raggedy Spot-Bilt spikes that Boog had worn since high school. After determining that he and Boog wore the same size, thirteen, Triandos directed Boog to his ample supply of Rawlings spikes that featured yellow kangaroo leather tops. "Son, take some," Triandos told Boog. Boog ended up getting five pairs. "I was in hog heaven," Boog recalled. The custom was for a player to write his uniform number on

Boog and Brooks Robinson in their youth, 1964. *Reprinted with permission of the Baltimore Sun Media Group. All rights reserved.*

the tongue of his shoes. "Gus was number eleven, and I was sixteen, so I just put a loop on the bottom of the eleven and made it a sixteen," Boog recalled. " I never forgot that. Gus made me feel like I belonged." Wearing his new shoes, he had a stellar spring training, batting .380. Boog thought he had made the club.

Paul Richards, the manager, thought otherwise. "Paul called me in his office and said, 'Son, I want to take you, but you are not ready. I know you don't understand, but trust me. You have got a ways to go, but you are going to get there. If we see that you are doing well, we will call you up.'"

It was not what Boog wanted to hear, but he reported to Rochester, New York, to the Orioles' top minor-league team. Instead of making a good impression there, he got off to a terrible start. He couldn't hit a curve ball. He was playing so poorly that he was close to being sent down to a lower-level farm team. Then Clyde King, the Rochester manager and former right-handed pitcher, came to Boog's rescue.

"The team was in Columbus, Ohio, and Clyde called me in his office and said, 'You and I are going out to the ballpark early tomorrow, and I am going to throw you curve balls until you can't see.' We went out to the ballpark, and Clyde had a good curve ball. He threw me about seventy curve balls. Then I would go out on the field and pick up the balls. I had hit a couple out, but not too many.

"He said, 'OK, we are doing it again.' The next time, there were fewer balls on the field to pick up, and more were hit out. Then he said, 'I am not going to tell you what is coming.' Up to that point, he had been throwing all breaking balls."

"All of a sudden, I found it. It was there. He would throw me a fastball, and bang! He would throw me a breaking ball, and bang! It was really all about balance. He taught me that you had to wait, had to be balanced, could not get out on your front foot."

Still wary, King told his player, "Let's see what happens in the game."

That night, Boog, with his timing back, had four hits. Then the onslaught started. He clobbered the ball. He ended up leading the league in home runs (thirty-two) and runs batted in (ninety-two), and at .324, he came within a few points of winning the league's batting title.

Some of his home runs were epic. "One night in Richmond, Luke Easter [a former Indians star then in the minors] and I hit back-to-back home runs over the scoreboard. That ballpark had been around since the 1930s and no one had hit it over the scoreboard, and Luke and I did it back to back," Boog said.

Boog's 1960 season ended on a sweet note when the team made an unexpected jaunt to Puerto Rico. A severe flood had ruined the ballpark in Charleston, West Virginia, the home park of a rival team in the International League. The Charleston team moved temporarily to San Juan, where Boog and his Rochester teammates played them in the final two weeks of the season. San Juan was sunnier than Rochester, and the seafood—spiny lobsters, crabs and fresh fish—found its way to Boog's plate.

But the biggest catch for Boog was his future wife, Jan Swinton, an attractive brunette from Rochester. The couple was set up by the bat boy of the Rochester team. "She was friend of one of the bat boys who said, 'You gotta meet this gal,'" Boog recalled. Their first date was a double date, at Al's Garden Grill, with the couples mismatched.

Jan had been set up with Barry Shetrone, Boog's roommate and a native of Glen Burnie, a Baltimore suburb. Boog had been set up with Jan's friend, Mary Lou Raif. As the evening progressed, it became apparent that Jan

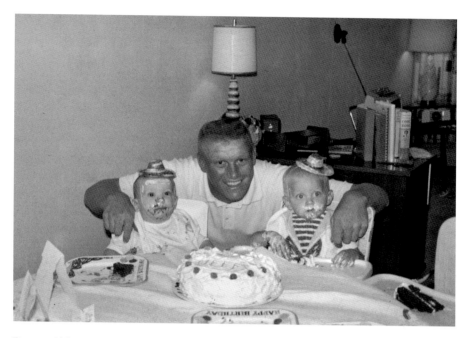

Boog and his son, J.W., celebrate an early, messy birthday with Jeff McNally. *Author's collection.*

and Boog were attracted to each other. "At end of the night, I said to Barry, 'We gotta make a deal here. I think I like Jan better than the girl I was with tonight.' And he said, 'I like girl you were with.' So I said, 'All right, now.'"

It turned out, in baseball parlance, to be a double switch. Jan and Boog became a couple, and Mary Lou later married Buster Narum, another minor-league teammate of Boog's.

It was no coincidence that the couples dined at Al's Garden Grill. Boog and Shetrone lived rent free in a small house behind the bar and restaurant. The two ballplayers had been befriended by Al and Donna, the owners of the establishment. The couple not only offered Boog and Shetrone free living quarters, but they also opened Boog's eyes to Italian cooking.

Boog recalled, "Barry and I were staying in a house in back of the place. Al would take his food deliveries in the morning. And sometimes when he wasn't there, we would take them for him. We would hang out with him, and he would make us breakfast. Al was a self-made gourmet chef; he made all his own sauces."

Decades after the demise of Al's Garden Grill, Boog still recalls the "exotic omelets" and sliced tomatoes he enjoyed on Rochester mornings.

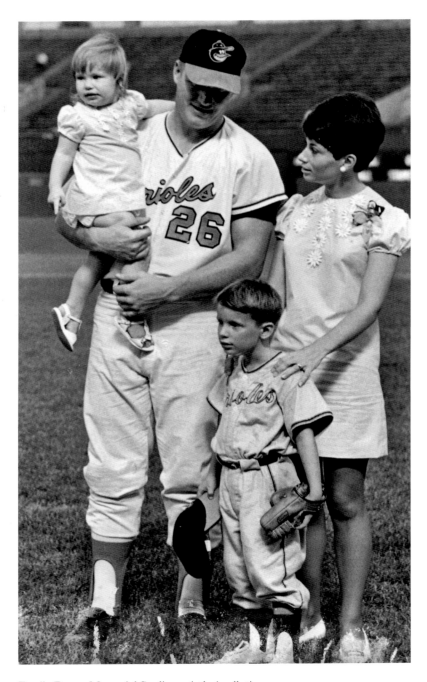

Family Day at Memorial Stadium. *Author's collection.*

In Rochester, Boog began seeing a lot of Jan. When he went away on road trips, he gave her the use of his car, the 98 Olds convertible, complete with a battery-powered record player. When the team bus rolled back into town, Jan would be there in the Olds to greet Boog.

Late in the 1961 season, Clyde King, the manager of Rochester, called Boog and Barry Shetrone into his office to tell them the Orioles were calling them up to the majors. The two players scrambled. They drove seven hours to Baltimore so Boog could stash his car there. Then they caught a flight to New York to be in Yankee Stadium for a night game. While Boog had felt he would eventually be called up ("I was having a hell of a year, almost won the Triple Crown in the International League"), it still surprised him.

After the 1961 baseball season ended, Jan came down to Key West for Christmas and to meet Boog's family. The young couple was spending the day at the beach when Boog picked some wild lilies, summoned his courage and proposed.

Jan accepted, and the couple planned to get married the following summer during the All-Star break. However, Boog soon got a temporary case of cold feet. He was a rookie, and the sages of the locker room advised him to stay single. "Guys kept telling me, 'Don't get married.' But I realized I had seen everything I wanted to see. And when you are a professional baseball player, you can live in the fast lane. But it was time to settle down."

The Orioles played Detroit just before the All-Star break in 1962, and during the short time off, Boog traveled over to Rochester for the wedding. The couple was married at six o'clock on Monday evening, July 9, at Ridgemont Country Club in Rochester. The next day, Boog and Jan drove to their new hometown, Baltimore.

Boog bought Jan a Chevrolet Corvair from Johnny Wilbanks, a colorful Baltimore character who sold cars from a lot at 4800 Harford Road and who dubbed himself "the walking man's friend." It marked the beginning of a long relationship both with Wilbanks, who would end up selling Boog a new Cadillac each year, and with Baltimore, a town where Jan and Boog would set up their household, raise a family and ultimately be embraced as favorites of Charm City.

CHAPTER 4
LITTLE NOTICED DEBUT

Baseball history was made the night twenty-year-old Boog Powell made his major-league debut in Yankee Stadium. But Boog didn't make it; Roger Maris did.

The Tuesday night crowd of 20,001 on September 26, 1961, and the baseball writers of America paid little heed when the blond kid just called up from the Orioles' Rochester farm team struck out late in the game as a pinch-hitter. Instead, attention was focused on the Yankee slugger chasing Babe Ruth's home run record. In the third inning, Maris knocked a Jack Fisher curveball into the upper deck just inside the right-field foul pole. At first, Maris didn't run; he stood at home plate next to Oriole catcher Gus Triandos and waited to see if the ball would stay fair. When it did, tying the sixty home run mark of Baltimore native Ruth, Maris trotted around the bases. He took the next game off, avoiding Orioles left-hander Steve Barber, and five days later hit his record-setting sixty-first home run off Boston's Tracy Stallard.

Boog was happy to have the spotlight fall on somebody else, even if it was a Yankee. When he walked into Yankee Stadium, the vast size of the structure scared him. "I went in there and looked around," he recalled, "and thought 'Oh my God! There could be seventy-five thousand people in here, three times as many people as there are [at the games] in my hometown.'"

Another frightening factor was the defensive assignment he drew the next day: left field. "I think I had played two games in the outfield in Rochester, and here I was starting in left field in Yankee Stadium," he

First baseman Jim Gentile (right) with Steve Barber and Boog, circa 1963. *Author's collection.*

recalled. First base, Boog's preferred position, was occupied by Jim Gentile, so late in the 1961 season, when the Orioles were out of contention for the pennant, they brought Boog up from the farm team and trotted him out to left field. Their expectations were low. Luman Harris, who had taken over as manager for Paul Richards, told the youngster, "Don't try to do too much. We know you haven't been playing left field all year, so just do what you can."

The newly minted left fielder met their low expectations. "I caught a couple of balls," Boog recalls. But more than half a century after his debut, he still has vivid memories of being "chewed up" by a line drive hit by Mickey Mantle. "Mickey hit a bullet at me, and it started knuckling and it hit me about four times—in the arm, the chest, the neck…I think he got a double out of it."

Newspaper accounts, however, report that Mantle, like Maris, had taken the night off when Boog first roamed left field. His line drive nightmare probably occurred on a subsequent visit to New York.

Boog admits that his first at-bats were a blur. "I was like a zombie," Boog recalls. "They could have thrown the ball behind me, and I would have swung at it. I was so nervous, and I shouldn't have been because I was having a hell of a year in Rochester."

Before coming to bat in the third inning, Boog gave himself a pep talk. "I gathered myself together and said, 'Come on now, this is bullshit.'" The talk worked, as Boog, facing Yankee pitcher Bill Stafford, sliced a single into center field, scoring teammate Russ Snyder from second with what proved to be the decisive run in the Orioles' 3–2 win over the Yankees. "I didn't hit it real good," Boog remembers, "but I still got a base hit."

The next day, newspaper readers in Baltimore picked up their morning paper to read, "Hit in the Third by Powell Wins Game." In his first full game in the majors, and with his first hit, Boog had made headlines.

He would continue to make headlines in the off-season and in the spring training session that started the 1962 campaign. "Birds Groom Power Boys," read a dispatch late in the 1961 campaign from the *Baltimore Sun*'s Lou Hatter, who wrote that Boog—along with a bonus baby, Dave Nicholson—would figure in the Orioles' emphasis in the 1962 season on "outside" baseball. That meant hitting baseballs out of the park.

During the gray Baltimore winter, fans were kept apprised of how the young slugger Powell was doing in games played in sunny Scottsdale. Even his slight injuries, such as a sprained wrist, merited coverage. "Hairline Fracture of Right Wrist Gives No Cause for Alarm," the *Sun* assured its readers just before Thanksgiving in 1961.

When the team gathered for spring training in Florida, Boog's powerful performance in the minors stoked the belief that this could be the year the Orioles would top the Yankees.

"This club has been close—right on the brink, so to speak—to winning the American League pennant the last couple of years," Clyde King, Boog's minor-league manager, told the *Sun*'s Jim Elliott. "I think that Powell this year could provide the impetus to put them over."

Boog's performance during spring training added fuel to the fires of optimism. Sportswriters were agog when, in batting practice, he socked baseballs so hard that they shot through the rope net strung in front of the Iron Mike pitching machine. Later, during a batting practice drill in Miami, Boog hit a 450-foot shot. *Morning Sun* readers were told of a towering blast that "cleared a 15-foot wall in right center, the scoreboard atop the wall, a clock above the scoreboard and a television station sign atop the clock."

Sam Bowens, Brooks Robinson and Boog rub bats with bones to strengthen the wood, circa 1965. *Author's collection.*

The twenty-year-old kid had become, Elliott wrote, "the chief Oriole topic of discussion in all the hotel lobbies, in the clubhouses, the dugouts and on the field. When he steps to the plate, the dugouts of both teams come to attention. When he walks across the field, opposing players' eyes follow him."

During that spring, he faced what were arguably baseball's best left-handed pitchers of the day: Whitey Ford, Warren Spahn, Sandy Koufax and Johnny Podres. He hit them well, going three for four against Spahn, two for two off Ford, one for three off Koufax and then one for three off Podres. He ended up hitting .354 in spring training to lead the team in hitting.

As teams broke camp and headed north to begin the 1962 season, the Associated Press sent out a story on April 1 that said that the most promising rookies of spring training were Ray Washburn, a St. Louis pitcher in the National League, and the Orioles' Boog Powell. The *Saturday Evening Post*, then one of the largest magazines in America, singled Boog out in its May 5 issue as one of its "People on the Way Up."

A gleeful hug from Robin
Roberts, star pitcher and
Boog's 1964 road roommate.
Author's collection.

As the clamor of acclaim grew louder, Boog tried to keep some perspective. "I tried not to pay attention to it," he remembers. "I didn't want to let anyone down." Yet there was some lingering doubt. "I was a bit apprehensive about facing major-league pitching because everybody said once you get to the big leagues, everything changes. And they were right."

While he pasted Whitey Ford in spring training, when Boog faced the Yankee left-hander in the regular season, it was a different story. Ford struck him out repeatedly, throwing pitches Boog "had never seen before."

During his first thirteen at-bats in the 1962 season, Boog, the touted slugger and the bright new hope for the Birds, had one hit.

Big-league pitchers prey upon weakness. If a hitter has a weak spot, a hitch, a quirk, the pitchers and their coaches will find it and pounce on it. As a rookie, Boog learned this the hard way. "They knew I had problems with the inside fastball," he recalls. "And I used to drag my bat and hands through the strike zone. But I really hit the ball hard to left, so they could not pitch me away. So they tried to get the ball in on me. If they got the ball in on me, they got me out—a lot."

So he worked on hitting the inside fastball, a technique that required a quick, efficient swing. "You can't have any wasted motion," Boog notes. "You have to have your hands back, and you have be direct to the ball—no messing around—hitting it out in front of you. You have to look for it, and all of a sudden it is there; you turn on it, and you hit two or three home runs."

Something like that happened in a game against the Minnesota Twins in Minneapolis on May 2, 1962. The slumping rookie had been bumped down from third to sixth in the batting order. But in the third inning, Boog caught up with a 1-1 pitch from Jim Kaat and sent it over the fence, some 375 feet away, for his first major-league home run. Later in the game, he launched his second career home run, a shot over the left-field fence off relief pitcher Ted Sadowski.

It was then that Boog quickly learned what happens after you start hitting home runs in the big leagues: pitchers make adjustments of various types. "Once you start hitting the inside stuff, all of a sudden they are throwing stuff away, and you have to remember how to hit away," he said.

There were other "corrections" pitchers made. "I hit my first home run against Jim Kaat," Boog recalls. "The next time I faced him, he almost hit me in the neck."

On those chilly spring nights in Minnesota, Boog, the Florida lad, looked down at his feet and found a strange substance: ice. "You would be running in the outfield, and you would discover you were running on ice; you could hear it crunching under your feet," he recalls. On such nights, the baggies came out. "We would put plastic baggies on our feet to keep them dry," Boog remembers. "But the problem is, your feet would sweat and still get wet."

Boog also tried another cold-weather tactic—wearing football spikes to increase traction in the slippery outfield. But he soon gave up that ploy. When batting, he would have to change footwear to baseball cleats, and the hassle wasn't worth it, he recalls.

Boog spent much of his rookie year learning the intricacies of playing the outfield. There was much to assimilate: how to track a fly ball in a cloudless sky, where to position yourself in different ballparks and how to anticipate where the ball would go. He learned quickly that his best friend on the field was a savvy, sure-handed shortstop like Ron Hansen and, later, Luis Aparicio. "There would be a hit in the gap, between left and center, and I would go out there and pick it up," recalled Boog." I had good hands, and then I would get it right to Ron or Louie. I had an accurate arm—not a strong one but an accurate one. So I would get it right to Louie as fast as I could and then let him throw someone out, and I would get an assist. One year I had thirteen or fourteen assists."

His rookie year was not what he had hoped it would be, nor did it bring home the ballyhooed prize, the American League pennant, that scribes had predicted. The Yankees won the pennant and went on to defeat the Giants in the World Series. The Orioles finished seventh out of ten teams in the American League. Boog batted .243 with fifteen home runs and fifty-three runs batted in. It was a solid, if not spectacular, start.

"I started off slow," he remembers. "I got hurt in Detroit—I bruised my thigh running into an outfield wall. I jumped for the ball and caught my thigh on the scoreboard. I probably should have gone on the disabled list, but I didn't; I day-to-dayed it."

Boog, like many ballplayers of the era, was reluctant to take himself out of the lineup. Part of it was pride, but another part was fear that someone would take his job if he sat down. "I had a bad habit of playing when I was hurt. Of course, we all did back then. It was all about job security, too. You know, Wally Pipp sat down one day, and Lou Gehrig took over, and Wally Pipp was never heard from again—and he was an All-Star player. We talked among ourselves, saying, 'Don't get hurt. If you get hurt, just go out there and fake it for as long as you can.' Sometimes it worked, and sometimes you dug yourself a deeper hole."

His introduction to the major leagues had been uneven—he had not delivered the clout many had predicted. But he was improving his skills. Moreover, he was becoming a solid member of the Orioles team and the Baltimore community.

Boog and his new bride, Jan, had moved into the Lan Lea apartments on York Road in Lutherville. On some nights, he would come home and happily find that Jan, an accomplished cook, had prepared one of his favorite dishes—fried chicken livers with sherry sauce.

His roommate in his rookie year was a veteran infielder, Johnny Temple. Over the course of the season, Temple introduced Boog to a new snack: oatmeal cookies covered with peanut butter. Boog had returned the favor by rescuing Temple and Marv Throneberry early one morning from a Baltimore police station after the two had been scooped up in raid on an after-hours lounge on North Avenue.

Another teammate on the 1962 roster, catcher Charlie Lau, would later become Boog's best friend, a companion on fishing trips in Florida and an expert hitting coach. He also had a mean recipe for fried mackerel, a recipe Boog would put on a kitchen card file and use for years.

Like many rookies, Boog had, in his first year in the majors, grown wiser in the ways of the world. While in New York, for instance, Boog delighted in visiting the Carnegie Deli, sampling its matzo ball soup and giant, overstuffed sandwiches.

Boog was carried off the field in Detroit in 1962 after catching his leg on the outfield fence. *Author's collection.*

Yankee veteran Yogi Berra, then playing only occasionally behind the plate, had sniffed out Boog's interest in food and struck up a conversation with the young Oriole as he stepped into the batter's box in a game back in Baltimore on June 19.

"Hey kid," Yogi said. "I hear you know about food." Meanwhile, the umpire recorded strike one.

"You been to any good restaurants lately?" Yogi continued. The umpire rang up strike two.

"There is a real good Italian restaurant right down the street from Yankee Stadium," Yogi added. "Strike three!" said the ump.

The next time up, Boog resolved he was not going to let Yogi distract him with chatter. "Yogi asked me a question," Boog recalled, "and then I said, 'Excuse me a minute, Yogi.' Then I got a double to right center off Ralph Terry." Later, Boog would score on a single by Hobie Landrath, and the O's won 3–1.

"After that, Yogi said, 'Screw you, I am not talking to you anymore.'"

Boog and Yogi would laugh about that exchange for years.

CHAPTER 5
YEARS OF GLORY AND BACKYARD BARBECUES

In the 1960s, Boog Powell came to fruition. Like a ripening heirloom tomato, he started slowly, but when the time was right, he was spectacular.

His slugging, along with that of the Robinsons—Brooks and Frank—led the Orioles to a World Series championship in 1966. It was the city's first, and the town was in ecstasy. Defensively, he locked down first base, his natural position, and twice finished second in the balloting for the most valuable player in the American League, an honor he would subsequently win.

On the domestic front, his life was expanding as well. He and Jan welcomed their son, John Wesley Jr., or J.W., into the world in 1963. J.W. was joined three years later by his sister, Jennifer.

In Baltimore, the Powell family had taken up residence at 1507 Medford Road, a little less than a mile north and east of Memorial Stadium, just off Loch Raven Boulevard. Several other Orioles (Brooks Robinson, Jackie Brandt, Jerry Adair, Davey Johnson and Dave McNally) also resided in the neighborhood. Often, after a baseball game, they would find themselves in the backyard of the Powells' row home, feasting on Boog's cooking.

J.W. remembers as a boy falling asleep in his upstairs bedroom hearing the distant cheers from the ballpark, only to be awakened a few hours later by the laughter coming from his dad's backyard get-togethers.

"We didn't make much money, so we all went out together," Andy Etchebarren, Oriole catcher and Boog's teammate, recalls. "Boog was a good cook, a big fellow who enjoyed life. He would have parties at his house

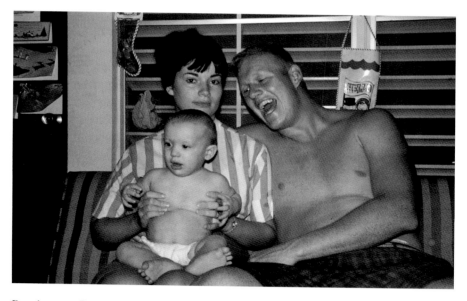

Proud parents Boog and Jan with J.W. in their Baltimore row home, 1964. *Author's collection.*

and barbecue for everybody. He introduced me to Manhattans and to vodka Gibsons with onions in them."

Boog's definition of a great night was "playing cards, getting a case or two of National Bohemian and sitting out in the backyard." (National Bohemian, a wildly popular blue-collar lager made by the National Brewing Company, happened to be owned by the Orioles' majority owner, Jerry Hoffberger.)

"All those houses were attached," Brooks Robinson recalls. "I bought my house from the Colts running back L.G. Dupre. They called him 'Long Gone' Dupre. Boog bought a house about two houses down from me. Boog partied better than anyone else. He lived large, but he was always ready to play every game."

Living close to the ballpark and to the families of other ballplayers had several benefits. "Jan and Connie got together," Brooks Robinson recalled, referring to Boog's wife and his own. "And kids played together."

Jennifer, now Jennifer Powell Smith, a senior loan officer living in Longwood, Florida, recalls that when she was a little girl, the Medford Road families would sit together in a section of Memorial Stadium reserved for relatives of Oriole players. "It was fun for us because we got to see all of the families of the other players," she recalled. "And we had the same ushers,

and they would bring Cokes and hot dogs. We loved Family Day, when they brought us sodas."

Initially, she was upset when her dad came to bat and the crowd hollered, "Booooog!" "I thought they were booing my dad, and I said, 'Mommy, why are they booing him?'" Her mother assured her that the calls were signs of affection, not derision.

Theoretically, the ballplayers could walk to work, but mostly they drove, a commute that took about three minutes.

Boog and Brooks also shared off-season duties making public appearances for the Orioles, showing up at men's clubs and similar venues around Baltimore. "You got twenty-five dollars an appearance plus two cents a mile," Boog recalled. Boog said he made occasional appearances but that "Brooksie did it almost every night."

Boog explored a variety of ways to make money in the off-season. For two winters, 1962 and 1963, he signed up to play baseball for the team from Mayaguez in Puerto Rico. In addition to a salary, he got the use of a car, a green 1957 Buick Roadster, big enough "to hold three families with playpens and go to the beach." Passions ran high among the fans in Puerto Rico. The games were rollicking affairs, with fans chanting, shouting and, every so often, hurling objects at opposing players. "One fellow threw a rum bottle at me once when I was at first base," Boog recalled. "He missed, and I picked it up and took a swig."

Another time, a bartender at a restaurant overlooking Phosphorescent Bay in La Parguera who was a fan of an opposing team plied Boog with cocktails in the hope that Boog would be unable to play or would perform at a subpar level in a game the following night. Instead, Boog had a big night at the plate, driving in several runs in a Mayaguez victory. Boog returned to the restaurant on the way back to Mayaguez. "The guy couldn't believe it," Boog said.

Fans in Puerto Rico, like fans everywhere, could be fickle. The first winter that Boog played in Puerto Rico, his team won the island title, and he and his teammates were treated royally. A jubilant crowd greeted the victorious team in the city square, surrounding the team bus on its return to Mayaguez. "We didn't know what to do," Boog said, "so we took all the money out of our pockets, hid it on the bus and then opened the bus door and just dove into the crowd. A big fellow caught me, and they carried me and the other players to a stage. I had never seen anything like it."

After his team had won the Puerto Rican title, taxicab rides were free, and everyone was his friend. The following winter, however, when the team failed

to regain the championship, the free rides and the hearty greetings were only distant memories.

After two winters in sunny Puerto Rico, the Powells began spending the off-season in Baltimore. After some negotiations with the Orioles, Boog landed a job as goodwill ambassador for Churchill Liquors, a wholesale distributor. Armed with an engaging personality and a sizeable expense account, he roamed the city signing autographs in liquor stores, appearing at banquets in local restaurants, smiling and telling stories.

The Orioles were not thrilled to have a ballplayer working for a liquor company and tried to get him to take a job in a First National Bank, where he could learn about money management. But the Churchill job paid $250 a week, twice what the bank was offering, and came with many perks, among them buying beverages at wholesale prices, a benefit Boog later shared with his manager, Earl Weaver.

"It was the greatest job ever," Boog recalled. "The salesmen knew they could take me anywhere. I had a well-rounded personality, and I enjoyed having a cocktail with the guys. I could get customers in the door, and as time went on, I had something like my own territory on Belair Road. There were four or five places, corner taverns, and Bo Brooks [a crab house], where I would go. Bo Brooks was one first places I started going to. After I told other ballplayers about it, they went there and all of a sudden you couldn't get close to it."

But living near Memorial Stadium in the off-season came with a drawback. If the Baltimore Colts were playing, weekend parking in the neighborhood was a nightmare. "If the Colts were in town, you had to start looking for a parking place on Friday," Boog recalled. "If you didn't get one by Friday, there was no place to park."

Once springtime arrived in 1964, Boog was leading the Orioles' attack. Skipper Hank Bauer put Boog in the third batting slot, reasoning in part that in addition to his power, Boog's big body would block the view of opposing catchers and give Orioles lead-off hitter Jackie Brandt and number-two batter Louie Aparicio better chances to steal bases. It seemed to help Aparicio, who swiped fifty-seven bases that year, but not Brandt, who stole only one.

Memorial Stadium was not an easy place to hit home runs. The deep power alleys, originally 385 feet in right and left center, required quite a poke, and balls tended to die on the warning track. Still, Boog connected for some massive shots. He smacked a ball over the hedge behind the center field wall in 1962, a wallop of some 470 feet, the first Oriole to clear that landmark. For a while, it was the longest home run hit in Memorial Stadium.

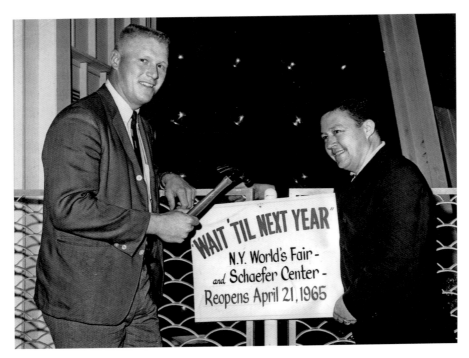

Boog working in the off-season promoting Schaefer beer at the 1964 New York World's Fair. *Author's collection.*

But in 1964, the Twins' Harmon Killebrew hit one in the same vicinity, and his home run was declared to have traveled 475 feet. "That pissed me off—they gave Harmon more footage than me," Boog said. "I said 'Come on, he's a visitor. I am here every day.'"

Despite this dispute, Boog and Killebrew became friends. Five years later, when Killebrew was named the American League's MVP in 1969, he told Boog that he, the Orioles first baseman, should have been given the award. Both men had impressive statistics that year. Boog knocked in 121 runs, hit 37 home runs and batted .304, while Killebrew knocked in 140 runs, socked 49 home runs and batted .276. Killebrew seemed to have the edge in slugging, but he was gracious. "Harmon told me, 'I got it, but you deserved it,'" Boog recalled.

The Orioles fell short of the Yankees in a run for the pennant in 1964 despite a strong showing down the stretch by Boog. Waylaid by an injured wrist—a malady that would continue to haunt him throughout his career—Boog missed fifteen games in August and early September. Shortly after

returning to the lineup, he launched an epic 475-foot home run over the center-field fence in Kansas City's Municipal Stadium, telling reporters after the game that his wrist still hurt. His wrist did not heal, but he continued to hit, batting .333 for September and winning accolades from manager Bauer. In summing up the '64 season, Bauer told reporters that the club had fallen out of the pennant race when its bats went quiet. The exceptions to this hitting draught, he said, had been Boog Powell and Brooks Robinson.

The next season, 1965, Boog slumped, and Bauer, in an exchange that Boog found insulting, ordered him to lose weight or pay a fine. From Boog's perspective, his weight was his business. When he was hitting well, no one questioned it. But when he struggled, his weight was seen as the culprit.

From the Orioles' point of view, his production had dropped off, and his bulk had slowed down his timing. Boog's size had long been an issue of contention for Orioles management. Even as a newcomer, then relatively thin, his eating habits had been topics of concern for Orioles brass. While touting the talents of then-rookie Powell, Oriole general manager Lee MacPhail had told reporters his only weakness were "a knife and a fork."

Perhaps it was an attempt at humor, but Boog did not appreciate it. He believed that Orioles management was fixated on his weight.

"If I was going good, it didn't matter what you weighed. They would send a trainer in there, and he would say, 'What do you weigh today?' I would tell him, and he would put it down. But when things were going bad, I had to get on the scale," Boog recalled. "And one year, I came up with shin splints, and Hank Bauer got pissed off. He sent Ralph Salvon in to weigh me, and I think I weighed 262. Hank said, 'You got two weeks to lose twenty pounds or it is going to be ten dollars a pound.'

"So I bust my ass. I am gonna show them. I was so tired by the end that I could hardly walk. I was hurting. I wore a rubber suit. The day of the weigh-in was a Sunday, a day game, and I got to the ballpark at around eight in the morning. I got in the whirlpool, and Jimmy Tyler set the whirlpool at about 105, which is pretty hot. I stayed in the whirlpool for almost an hour. I got out looking like a lobster.

"I went in and got on the table, and Ralph Salvon covered me with a blanket. I lay there and sweated and kinda took a nap. Finally, I said, 'Ralphie, let's get it over with.'"

By his recollection, Boog weighed in a mere half pound over the goal. Press reports say he was over by a pound or more.

The untold story, Boog says, was what happened next. When he heard that Orioles executive Harry Dalton was going to charge him for the overage,

Boog confronted Dalton. "I was hot. Harry Dalton was there. He told me they were going to take it out of my check. I went in and got a five-dollar bill and threw it at him. He wouldn't pick it up."

Boog finished the year with seventeen home runs, 72 RBIs and a .248 batting average.

Years later, recalling the battles over his weight, Boog was both reflective and resentful: "Someone thought my ideal weight was 240. But when I was going good, Ralphie [Salvon] would weigh me at 275, and not a word was said. Most years I was at 270. [Owner] Jerry Hoffberger was worried I weighed too much and sent me and Jan to a session with an endocrinologist and later a psychologist." During one session, the psychologist presented Boog with a piece of rubber that resembled a sandwich and asked him to reflect on it.

The session with rubber food pretty much ended Boog's visits. "I tried to go along," Boog recalls, but the rubber food was too much. Moreover, he was confident of the way he walked through life. "There is a lot to be said about how I live my life. I enjoyed a few beers after the game. It was a way of relaxing. We would talk about the game. We probably had three beers before we had our socks off."

Drawing up a chart comparing Boog's weight with his batting average and home run totals seems to prove little. The weight on Opening Day programs is suspect. Baseball Almanac listed Boog at 240 pounds every Opening Day program of his career. *Sports Illustrated*'s Opening Day lineups list him at 230 throughout his career. Age might be a more likely factor in production, but it is uneven. His best years the plate were 1966, '69 and '70, when he was twenty-five, twenty-eight and twenty-nine years old, respectively. However, in 1975, at the age of thirty-four and playing for Cleveland, he had another stellar year, was named Comeback Player of the Year and had better statistics than he did at twenty-six and twenty-seven.

In 1966, Boog's batting numbers soared largely because 183 pounds were added to the Orioles lineup in the person of Frank Robinson. Robinson came over to the Orioles in a deal with the Cincinnati Reds. That made the Orioles batting lineup much tougher to pitch to.

Truth be told, Boog at first had mixed feelings about the trade. To get the Cincy slugger, the Orioles had traded Milt Pappas to the Reds. "Milty was a friend and a hell of pitcher," Boog recalled, pointing out that Pappas would go on to win ninety-nine games in the National League.

Nonetheless, Robinson brought a fierce demeanor to the club, an attitude that Boog appreciated. Robinson chastised his new teammates for chatting with opponents during a game. "Frank said, 'Screw those guys, talk to them

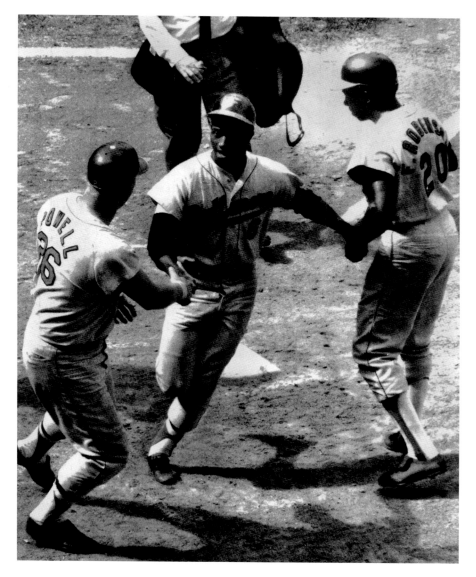

The powerful 1966 Orioles lineup is on display as Paul Blair is congratulated by Frank Robinson and Boog. *Author's collection.*

after the game.' It made sense to me," Boog recalled. "We would be smiling at you one minute and beat your brains out in the next."

In addition to tough talk, Robinson swung a big stick, an attribute Boog quickly noted. "When Frank came over to the club, we were down

in spring training, and Frank hit one over the palm trees," Boog recalled. "I turned to Etch [Andy Etchebarren] and said, "Etch, I think we just won the f—ing pennant.""

Boog started the 1966 season slowly, but on May 1 in Detroit, he hit a 415-foot line-drive home run off Tiger hurler Joe Sparma that ignited him and the team. "I came back in the dugout and said to Frank, 'Here we go, I am feeling good.' And away we went. When Frank didn't do it, I did it or Brooksie [Robinson] did it. And if Brooksie didn't do it, [Curt] Blefary did it. And when Blefary didn't do it, [Paul] Blair did it."

The Orioles lineup was deep and talented, and Boog knew opposing pitchers did not have the luxury of pitching around a hot hitter: "Paul Blair was hitting second. With Frank and me behind him, nobody was going to walk him. And you don't walk Frank to get to me."

During the '66 season, Boog's bat was on fire. He drove in eleven runs in a July double-header and was named player of the week by *Sports Illustrated*. In mid-August, he hit three home runs in one game at Fenway Park. Later that month, in Baltimore, he and journeyman Vic Roznovsky hit back-to-back pinch-hit home runs in the ninth inning of another game against the Red Sox.

Players on the 1966 Orioles liked one another. Winning helped, but they also had good times together off the field. In the post-game locker room, Frank Robinson presided over a kangaroo court. Wearing a mop as a wig and holding a Louisville Slugger bat, Robinson dished out one-dollar fines for bad behavior—anything from wearing popsicle-colored pants (Bobby Floyd), to yawning on the bench (George Bamberger), to taking too long to pitch a game and shortening the cocktail hour (Dave McNally). Boog and Charlie Lau were fined by the court for cleaning fish in the Memorial Stadium shower. "We had had caught some rock," Boog recalled, using the local nickname for striped bass. "We cleaned them and cooked them that night." The court, he added, "kept everybody loose."

There was revelry on the road as well. Eddie Fisher, a pitcher and Boog's roommate, remembers a night in 1966 in the Hotel Leamington in Minneapolis when he and Boog talked a man out of his cash-filled Stetson hat. "We had been out, had a couple of beers, and we came back to the hotel and ran into a fellow in the lobby who had had a few more beers than we had," Fisher recalled. "He was wearing this very fancy Stetson hat. There was this push broom nearby, and I picked it up and started pushing it toward him. I asked him if he wanted to trade the broom for his hat. He pulled that hat off and in a minute was going out the door, pushing that broom."

Keeping loose in the clubhouse, Curt Blefary (left) dunks coach Gene Woodling in the whirlpool with help from two unidentified teammates in 1966. *Reprinted with permission of the Baltimore Sun Media Group. All rights reserved.*

Once in their hotel room, Fisher and Boog examined their new chapeau and, to their surprise, found four twenty-dollar bills in the brim. They returned to the lobby to look for their broom-pushing buddy, but he was long gone.

Fisher, in a telephone interview from his home in Altus, Oklahoma, recollected that he and Boog transferred the found cash into their meal money accounts.

But Boog has a different recollection. He said the cash helped pay for a hotel door that he and "Fish" had knocked down in a high-spirited tussle with teammates Andy Etchebarren and Curt Blefary in the same hotel. "It was late, and Fish and I were making a little noise in our room. And Blefary and Andy, who were in the adjoining room, started yelling at us to shut up or they were going to call [manager Hank] Bauer on us," Boog recalled. "Insults were hollered. I told them if they didn't shut up, we were going to knock down the door connecting the two rooms and come in and beat the hell out of them. They didn't shut up, so I said to Fish, 'Let's go.' So we hit that door, split it in half—and it was no chickenshit door—burst into their room and gave them hell. That door cost us $760. So I started a fund—a building fund—to pay for it. We must have used some of the money from the hat to start the fund."

On another night, a party at the Baltimore County home of a local funeral home owner who was a loyal Orioles fan got too rambunctious and almost resulted in tragedy. Frank Robinson, the eventual Triple Crown winner (leading the league in batting average, home runs and RBIs), was tossed in the pool. To this day, there is some debate about who tossed him in. Andy Etchebarren told Boog that Boog threw Robinson in. Boog cannot remember, but he does recall seeing Robinson, who could not swim, floundering on the bottom of the pool. Boog contends he was all set to dive in and save his teammate, but Etchebarren beat him to it. Robinson was pulled from the pool and was not harmed. But somehow during the festivities, Boog ended up with a gash on his forehead.

Boog went to a hospital emergency room to get treatment, but in an effort to avoid publicity, he gave the hospital an assumed name. He was stitched up and returned to the party, but the hospital staff wasn't fooled. "Big as he was, they knew who he was," Etchebarren recalled. Word of the star first baseman's visit to the hospital emergency room soon leaked out. An edict from the Orioles swiftly followed: no more parties until the team secured a pennant.

When the Orioles did win the pennant in Kansas City on September 22, a great deal of merriment was unleashed, and Boog did a lot of the unleashing. In addition to participating in the usual champagne showers in the locker room, Boog, according to reports in the *Sun*, picked up at least one reporter and placed him in a whirlpool. Years later, Boog does not confirm

or deny dunking a reporter, saying that he can't remember. But he did recall adding a touch of yellow mustard—or maybe more than a touch—to a coat worn by Kansas City broadcaster Monte Moore.

Boog had spotted Moore entering the jubilant Orioles locker room clad in a bright green blazer. "It seemed to me that bright green coat would look better with some yellow mustard," Boog recalled. Boog applied the mustard and admired his work, but Moore was not pleased. "He never talked to me after that," Boog said.

More hijinks were in store later that night. Still celebrating their good fortune, Boog and several teammates, including relief pitcher Moe Drabowsky, headed to Dreamland Barbecue, one of Kansas City's many fabled emporiums of smoked meat. After enjoying the ribs and the brisket, they stepped outside Dreamland and onto the sidewalk. "Moe took out a pair of dice," Boog recalled, "and he started rolling them on the sidewalk, saying, 'Come on seven, come on seven.' Guys came out of nowhere, and within minutes there was a full-scale craps game going on right there on the sidewalk."

Rolling dice on the sidewalk for money was not a legal activity, and at Boog's urging, Drabowsky reluctantly agreed (after several rolls of the dice) to get in a cab. They Orioles departed the scene, and not a moment too soon. "As soon as our cab rounded the corner, here came the Kansas City cops with their lights flashing," Boog recalled. "That one was close."

The Orioles surprised gamblers as well as most of the baseball world in the '66 World Series. Not only did the touts have the Los Angeles Dodgers as 8–5 favorites to vanquish Baltimore, but virtually no one figured the Orioles would beat the Dodgers and their pitching aces, Sandy Koufax and Don Drysdale, in four straight games. But they did, with Orioles pitchers not allowing a single Dodger run in Games Two, Three and Four.

In addition to lights-out pitching by Drabowsky, Jim Palmer, Wally Bunker and Dave McNally, the Orioles sluggers delivered timely hitting. Frank Robinson and Brooks Robinson knocked three balls out of the park during the four games, including back-to-back homers in Game One. Boog had a good series as well, getting a hit in every game and hitting .357 for the series to lead the club. In the first game in Los Angeles, he hit a double and almost took a tumble when the first-base bag gave way as he stepped on it. He even bunted in the eighth inning of Game Two, setting up a two-run inning that closed the door on a 6–0 Orioles win. In Game Four, he smacked a ball over the center-field fence in Memorial Stadium, but Dodger outfielder Willie Davis, who had made three errors in the series, made a spectacular play reaching over the fence and snagging the drive for an out.

Boog was doing all this slugging with a broken ring finger on his left hand. The finger had been broken late in the season when Detroit hurler Denny McClain hit it with a fastball, and it had not healed by the time the World Series began. "I was trying to wear a splint, but I couldn't," Boog recalled. "I got injected with novocaine before the game. I got a hit in every game, but I wasn't 100 percent."

Yet when the Orioles beat the Dodgers 1–0 in Game Four at Memorial Stadium to become world champions, Boog, like many folks in Baltimore, was feeling no pain. In the raucous celebration in the Orioles locker room, Boog grabbed a bucket and aimed its contents at his teammate and neighbor Dave McNally but missed. The errant liquid doused several reporters, among them Jim Murray, a *Los Angeles Times* columnist known as the "pope" of sportswriters. Murray took the dousing in stride, writing, "Since he threw the entire contents of a pail which consisted of equal parts champagne and water all over my best suit, you will understand I am not being totally objective when I suggest to you that the most impressive figure in the late, un-great World Series was a massive hunk of bone and flesh called Boog Powell."

The United Press International and the *Sporting News* named Boog the Comeback Player of the Year, and that spring, he signed a new contract with the Orioles that paid him $38,000 a year.

As sweet as the 1966 season was for Boog, the following year was a sour one. In 1967, Boog got off to an abysmal start and never fully recovered, ending the year batting .234 with thirteen home runs and fifty-five runs batted in.

The team swooned as well, and embattled manager Hank Bauer vowed to reporters that he was "going to be tougher" on the players next year, including instituting bed checks.

This crackdown was a change of managerial style for Bauer, a skipper Boog liked. "He once told us, 'If you players come into a bar and see me there, don't just leave. First buy me a drink, then leave,'" Boog recalled, adding that he had strictly followed the rules of Bauer's barroom decorum.

Bauer also had rules about dress. "He expected us to look and act like major-league ballplayers," Boog said. "We did. We always wore coats and ties."

Opposite, top: Dousing all, Boog empties a champagne bucket after the 1966 win. *Author's collection.*

Opposite, bottom: Tuxedo night with Hank Bauer, George Scott, Earl Wilson and Archie Manning, circa 1964. *Author's collection.*

But in 1968, the team was again playing poorly, and Bauer, who had never had a curfew for his players, was under pressure to do something, so he ordered a coach, Billy Hunter, to make sure the players were in bed. Boog was out when Billy came a knocking at his hotel room.

"Billy said, 'Where were you?' And I said, 'What do you mean?'" Boog recalled. "Billy said, 'We did a bed check.' And I said, 'My bed was there, wasn't it?'"

In midseason, Bauer was fired as manager and replaced by Earl Weaver. "We thought the world of Hank, but we just weren't playing well. All of a sudden Earl was there," Boog said.

Earl allowed Boog to steal bases, something that few opponents expected from a man his size. "Earl gave me the green light. He told me if they weren't watching me to take off, and I did," Boog said. By mid-September, he had five steals, and sportswriters were calling him a "whippet" on the bases.

But the thievery came with a cost. When sliding into a base, Boog had a tendency to land on his wrists, injuring them. The Orioles tried several techniques to keep him from hurting himself. One involved sponges. "They used to give be big pieces of sponge to carry, and that worked. But the times I didn't do it, I hurt myself." Word came down to "keep Powell off the ground." His "whippet" phase ended.

There was one other highlight for Boog during the rather dull '68 season. He almost picked Yankee Joe Pepitone off first base using the hidden ball trick of secreting the baseball in his glove.

"Pepitone was a smartass. He was always wanting to bet $500 a home run on who would hit more during the season. I never bet him, but I should have because most seasons I beat him by ten or twelve home runs," Boog recalled. That is a slight exaggeration. In 1968, Pepitone hit fifteen homers, while Boog hit twenty-two. Still, Boog came close to embarrassing the Yankee.

"I had the ball hidden in my glove, and he was going to wander off the base. And then Emmett Ashford [the first base umpire] called time out. I said, 'Emmett, what did you do that for?' He said, 'Because you have the ball.'"

"I tried that a hundred times," Boog recalled. "The first base coach usually gives it away. And this was my only chance to pull it off, and Emmett calls time out."

In 1969, Boog clobbered the baseball, and the Orioles soared. They jumped out to an early lead and never looked back, winning the American League East by nineteen games.

In 1968, Boog had batted .249 with twenty-two home runs and 85 RBIs. But in 1969, he hit thirty-seven home runs and had 121 runs batted in. His

teammates named Robinson also had stellar years. Brooks had twenty-three homers and 84 runs batted in, and Frank socked forty-nine home runs and knocked in 122 runs.

Some of the revival in Boog's hitting was due to Charlie Lau, an Orioles catcher and later a hitting coach with the Orioles, the Kansas City Royals, Oakland Athletics, Chicago White Sox and New York Yankees. "Charlie was my dearest friend," Boog said. "We fished together, we dove together in Florida. Charlie taught me how to throw a cast net and how to fish for bonefish, and we talked an awful lot about hitting."

Lau would go on to become one of baseball's most celebrated hitting coaches, a man whom Kansas City Royal slugger George Brett credits with changing him from a lowly .210 plugger into a Hall of Fame batting champion.

Lau's genius, Boog recalled, was a mixture of emphasizing physical techniques and mental acuity. "There were physical things he taught, such as keeping your hands back," Boog recalled. "He said if your hands aren't back, you can't be balanced—especially when you start to stride." Then there was getting your head right. "He taught how to think as a hitter," Boog said. "Not exactly what pitch to look for, but what was happening to you at this at-bat. All the physical things that you worked on in batting practice had to be in place when the time came. But when you are at bat, you have to think, 'OK, what is our situation here? You've got runners on first and second, with one out. So the pitcher is going to try to get me to ground into a double play. So I should be looking for something down, and make him bring the ball up.' Charlie would tell us this, and invariably they all came true."

Another strong point of Lau's was his low-key approach. "He watched everything but did not say a whole lot," Boog recalled. "I would be hitting batting practice and hit a couple in the upper deck in right field. He would be standing behind the pitcher, and he wouldn't say anything; he would just point to his head. I knew exactly what he meant: he wanted me to get my head back in the game, to take a couple of shots to left field."

Under Lau's tutelage, Boog had arguably his best year at the plate, hitting thirty-seven home runs, knocking in 121 runs and compiling a batting average of .304, the only season he would finish over .300.

Lau's instruction also helped Mark Belanger, lifting the batting average of the normally light-hitting shortstop almost 80 points, from .208 to .287.

Boog was shocked after the '69 season when the Orioles and Lau could not come to terms and Lau moved on.

"I came to Charlie and said, 'Why did you want to go?'" Boog recalled. "Charlie said he didn't want to go. He asked for an extra two thousand

dollars, and club wouldn't give it to him. It became a battle of wills. I told him if he had let me know, I would have given him the two thousand, and Belanger would have, too."

Lau and Boog remained friends after Lau left the Orioles. "We would see each other five or six times a year, in the winter in Florida." Lau died in 1984 at age fifty, a victim of colon cancer. His passing, Boog said, "broke my heart."

Lau's admonition to think at the plate served Boog and the Orioles well in the first game of the 1969 championship series against the Minnesota Twins. The game almost ended in a loss for the Orioles. With his team trailing by a run in ninth, Boog stepped to the plate.

"They had been pitching me away all day and had had pretty good luck," Boog recalled. "I fouled off about three pitches and then said to myself, 'They are coming in.' They came inside, and I didn't hit it good, but I did hit it good enough." His home run tied the game, and the Orioles won in extra innings.

Years later, Billy Martin, the manager of Twins in 1969, who had called the pitch from the dugout, regaled Boog about his ninth-inning homer.

"Billy was really pissed at me. We were doing the Miller Lite commercials together, and he said, 'You know you ruined my life. You had no business hitting that home run. We knew you wouldn't be looking for that pitch,'" Boog recalled.

"It was a fastball," Boog remembered, adding that his homer was not a towering shot. "I think there was a little green paint on the back of the ball, and it hit the fence going out. But that counts just as much."

The Orioles went on to sweep the Twins in three games in the playoffs but then fell victim to the surprising New York Mets. Led by pitchers Tom Seaver, Jerry Koosman and Gary Gentry and aided by diving outfield catches made by Ron Swoboda and Tommy Agee, the Mets defeated the Orioles in five games to win the World Series.

Boog hit .385 against the Twins, but like most of the Orioles, he had trouble hitting the Mets pitching and batted .263 for the World Series.

Family troubles also figured in Boog's poor World Series performance. He had bought his father, Red Powell, a first-class ticket to fly to Baltimore from his home in Lakeland, Florida. That purchase, Boog recognized later, was a mistake. His father had a drinking problem, and in first class, the liquor flowed freely. Red arrived in Baltimore not only inebriated but, according to airport officials who telephoned Boog, also in cardiac arrest.

Boog got the call just before Game One of the World Series. Once his father was sober, his condition improved, and he was soon taken back to

Florida by relatives. But Boog was shaken: "It was rough. You know, they call you and say your dad is in cardiac arrest at the airport. Then they brought him home, and he was all right. That was tough. I would like to think it didn't affect my performance in the series, that I wasn't obsessed with it. But the more I think about it now, I think maybe I was. I didn't feel right."

Boog's relationship with his father was troubled. As a boy, he and his brothers strove to make their dad, a former prize-winning boxer, pleased by competing well in sports. Their dad made it a point to attend his sons' games, and Boog describes him as "a good father." Proud though he was of his sons, Red Powell had a demon—alcohol—and it got him into trouble. As the years wore on, Red Powell's drinking grew increasingly troublesome. At one point, Boog allowed his father to live with his family in their off-season house in Miami, on the condition that his dad stop drinking. "I took him to Miami," Boog recalled. "We had a nice house down there, and I told him, "Daddy, you have got to cut back on the drinking. He said, 'Oh son, I can do that.'"

But he couldn't. His father kept drinking, hiding bottles of booze throughout the house, until eventually he left Boog's home and moved back to Lakeland. After several bouts with depression, he died of heart trouble in 1969, not long after that disappointing World Series.

After the turbulence with his father and the shock of losing the World Series to the Mets, it was, Boog recalled, "kind of a lonesome time. The whole town was expecting us to do more than we did. We felt like we had let everybody down."

But Boog and his World Series teammates were buoyed when they arrived at Baltimore's Friendship Airport from New York and were greeted by a crowd of five thousand fans cheering the team and at one point chanting, "We want Boog."

"It was a very moving thing," he recalled. "I will never forget that; it was one of the greatest things that had happened to me in my life. There is a real solid baseball base in Baltimore—there is no doubt about that. When they cheered, 'We want Boog,' I was crying like a baby."

It was a bittersweet ending to the 1960s for Boog, but better days and a world championship were just ahead.

CHAPTER 6
SWEET START TO THE '70S

The 1970s started sweetly for Boog. He was the most valuable player in the American League and the starting American League first baseman in the 1970 All-Star Game. His team would play in two World Series and win one. He and his teammates reveled in a triumphal tour of Japan. He and Jan welcomed their youngest daughter, Jill, into the world in 1971.

Yet the decade was also marked by disappointments. After several stellar years early in the '70s, Boog was slumping in the mid-1970s, and Baltimore fans were hollering, "Boo!" rather than, "Boog!" The Orioles were not-so-secretly trying to trade him and finally succeeded, sending Boog and Don Hood to the Cleveland Indians in 1975 for a catcher, Dave Duncan, and an outfielder, Al McGrew. Reunited with Frank Robinson, then the Indian skipper, and benefiting from a painful and unique treatment for his sore shoulder, Boog rebounded, socking twenty-seven home runs and winning Comeback Player of the Year honors for the second time in his career.

But after an uneven year in 1976 in Cleveland, he was sent to the Los Angeles Dodgers in '77. There he found some joy as a fan favorite, but mostly he languished as a pinch-hitter and ultimately hung up his spikes on August 31, 1977, a day he calls "one of the happiest" of his life.

Still smarting from their loss to the Mets in the 1969 World Series, the Orioles approached the 1970 season with a fierce intensity. "Birds Aflutter on Boog's Batting Boom" read the headline in the *Sporting News'* March 28 article describing some of Boog's mammoth shots that impressed veterans

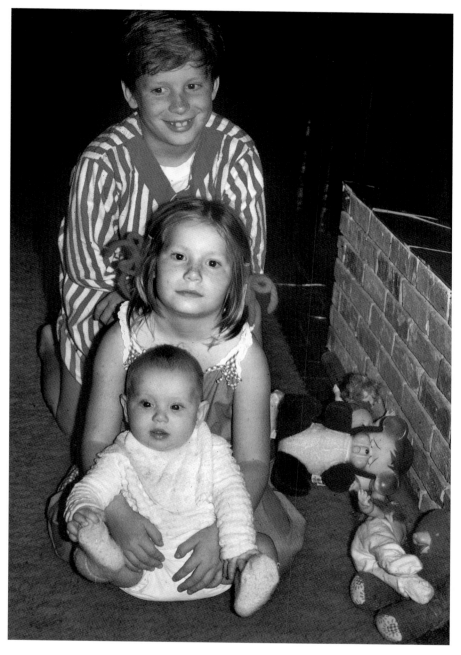

The Powell children—J.W., Jennifer and Jill—in their Towson home, circa 1971. *Author's collection.*

such as manager Earl Weaver and broadcaster Chuck Thompson. "It is a distinctive sound when he lays the bat on the ball," Thompson said. "There is a seasonal cycle to the Birds' fortunes," sportswriter Phil Jackman noted in the *Sporting News*. "If Boog is cold in the spring, it is a bad year for the Orioles. But if he is hot, hitting well, the Birds soar."

In 1970, Boog and the Birds were gliding. He had a good May and then cooled off a bit around July 4, when he was dropped to fifth in the batting order. But two weeks later, his stroke was back. Instead of batting fourth, behind Frank Robinson, Boog was moved to the third slot in a July 18 game against the Cleveland Indians.

"Boog has not been getting any pitches to hit," Weaver explained to sportswriters. "With Boog at bat and ahead on the count, a pitcher won't be too quick to give up a walk if he sees Frank Robinson over in the on-deck circle." The move paid off that night, as Boog slammed two home runs and a single off Cleveland right-hander Steve Dunning. Boog had lobbied Weaver to put him in the third spot. "I tried to convince him to put me in front of Frank—I would get more fastballs to hit," Boog recalled. But Weaver remained unconvinced, and the switch was a sometime thing.

Nevertheless, Boog hit .300 or better from May 1 until the final game of the year, a matchup in Baltimore against the Washington Senators, then managed by Ted Williams. Boog needed a hit to secure the much sought-after season-ending mark of .300. He walked twice and struck out once against Dick Bosman. Then, in the seventh inning, with the game tied 2–2, Williams pulled Bosman and brought in left-hander Dennis Riddleberger, who dispatched Boog.

Joking with reporters after the game, Boog said, "That fink, Ted, brought that guy in just to retire me." When told by reporters of Boog's remark, Williams laughed, saying it was a baseball move and that he was not aware that Boog was shooting for the .300 mark.

Years later, Ben Bradlee Jr.'s 2013 book *The Kid: The Immortal Life of Ted Williams* depicted Williams as tightly wound. Boog agreed with that assessment, saying he had fished with Williams in Florida and seen firsthand that Williams was an extremely competitive person.

Opposite: Beating the Twins in the 1970 playoffs. Boog and Don Buford admire the muscles of home run–hitting pitcher Mike Cuellar, and Boog collides with Twins catcher George Mitterwald. *Author's collection.*

Boog posing with Cincinnati Reds catcher Johnny Bench during the 1970 World Series. *Author's collection.*

Boog finished the 1970 regular season with a batting average of .297, thirty-five home runs and 114 runs batted in. The Orioles team, featuring the Robinsons, Paul Blair, Andy Etchebarren, Merv Rettenmund, Don Buford, Davey Johnson, Elrod Hendricks, Clay Dalrymple and Mark Belanger—as well as pitchers Jim Palmer, Dave McNally, Mike Cuellar, Dick Hall and

Moe Drabowsky—coasted to the American League East title. They won 108 games, finishing 15 games ahead of the second-place Yankees.

Next, it was the league championship series against the Minnesota Twins, where Boog slammed a home run in the first game of the series. But his poke was overshadowed by a grand slam hit by pitcher Mike Cuellar. Nonetheless, Boog led the team in hitting for the series, batting .429 with six runs batted in, and the Orioles took the series in three games straight.

The 1970 World Series against the Cincinnati Reds would become known in Baltimore lore as the Brooks Robinson series. In the five-game series, the Orioles third baseman made spectacular play after spectacular play, ranging to his left and to his right, snagging line drives and short hops and robbing Reds sluggers Johnny Bench and Lee May of base hits. He also hit two home runs, batted .429, drove in six runs and was named most valuable player of the series.

But Brooks's pal and teammate, the big fellow at first base, had an outstanding series as well. In the first game, Boog hit a two-run home run that helped the Orioles overcome a three-run deficit and go on to win 4–3. In the second game, Elrod Hendricks hit a timely double, and Boog smacked another home run to give the Orioles a 6–5 win.

"The first home run was Mickey Mouse," Boog recalled. "It wasn't a classic. It was down the left-field line, a breaking ball up, and I just hit it. The next day, I hit one in the upper deck in Cincinnati. That was where the big boys go. I was pretty proud of that."

He also was proud of his fielding, catching throws that were a little high or a little low and making his third baseman, Brooks Robinson, look good.

"He was a wonderful target to throw to," Brooks Robinson said of Boog. "He had good hands. He was big and limber and moved around well."

"I remember that first ball that was hit to me in the '70 World Series," Brooks continued. "It was like a twenty-four-hopper that I think [Cincinnati shortstop] Woody Woodward hit. I made a high throw to Boog for an error. You know if you make a throw to Boog that is too high, it has to be very high. But everything else turned out pretty good for me in that series."

During the season, Boog razzed Brooks about the third baseman's occasional errant throws to first, keeping a score sheet in his locker. "He kept track of all the bad throws I made to him," Brooks recalled. "At the end of year, he said, 'Hey Brooks, you made about fifteen errors and I saved you about ten, so you owe me a Gold Glove.'"

After the 1970 World Series, Boog continued ribbing his teammate, saying that after making sensational stops, Brooks played "bouncy ball" when he threw to first.

Left: Catching Johnny Bench's pop foul barehanded during the 1970 World Series. *Author's collection*.

Opposite: Relaxing in Florida in the off-season, Boog trims a hedge and fishes with his daughter Jennifer. *Author's collection*.

"*Sport* magazine gave Brooksie a Corvette for being most valuable player in the series," Boog recalled. "I told him, 'I want half the car.'"

In addition to scooping up low throws, Boog made another outstanding defensive play.

As Boog was pursuing a foul pop-up hit by Johnny Bench in Game Four near the Cincinnati dugout, the ball bounced out of his glove and into the air, and Boog snatched it with his bare hand. "The ball went in my glove, and I tried to stop from going into the Cincinnati dugout. I think Pete Rose was waiting for me in there, and that didn't look welcoming," Boog recalled. "In my stopping, my glove acted like a trampoline and tossed the ball up. I looked up and it was right there in front of my face, and I grabbed it. I surprised myself on that one."

The Orioles dispatched the Reds in five games and were crowned world champions. In November, Boog breezed to the title of American League MVP, garnering seventeen of the twenty-four first-place votes from the twenty-four-man committee of the Baseball Writers' Association of America. Runner-up Tony Oliva of the Minnesota Twins had five first-place votes. Boog had compiled better statistics the year before—121 runs batted in, thirty-seven home runs and a .304 batting average—but had lost out to Minnesota's Harmon Killebrew.

After Boog won the award, Earl Weaver told the *Sporting News* that he had been nominating Boog "for MVP since I got here." But privately, Weaver told Boog that Don Buford was his pick for MVP.

Life was good for the Powell family, who retreated after the series to Miami, where Boog had built a home on 104th Street four years earlier. There he spent the off-season enjoying the sunshine, the fishing and the cooking.

In 1971, the Orioles made it back to the World Series, this time against the Pittsburgh Pirates. The return trip had been bumpy for both Boog and the Orioles. Hampered by injuries—a hairline fracture of his right hand and a rib-jarring collision at second base—Boog struggled at the plate. In late June, his boss, Earl Weaver, issued a "hit or sit" ultimatum to Boog, a motivating tactic Boog did not appreciate.

"Earl called me into his office one time and said, 'By not hitting, you are keeping Mark Belanger on the bench.'" The manager's

logic was that the combination of Boog's slump and the light hitting of the Orioles shortstop prohibited the manager from putting both men in the lineup. Weaver also knew that Boog was loyal to his teammate. In effect, Weaver was trying to guilt Boog into hitting. The ploy didn't work. "I was trying too hard," Boog recalled. "I was frustrated and had physical problems."

The Orioles had started slowly as well. But an ugly, brawling game in Chicago's Comiskey Park at the end of May proved to light a fire under the team. With the Orioles sporting a healthy lead in the second game of a double-header, Don Buford, who had slugged two home runs in the game, was hit in the back in the eighth inning by a fastball thrown by White Sox hurler Bart Johnson. Buford charged Johnson, and both benches cleared, but order on the field was soon restored. In the bottom of the eighth, however, angry fans seated in the left-field pavilion belted Buford with debris, including the slat from a seat. The barrage continued in the top of the ninth as Buford prepared to come to bat. When one belligerent threw a corncob at Buford, the player approached the box seat railing. Then, according to Lou Hatter's account in the *Sun*, another fan leaped the railing and attacked Buford from behind. Boog was about ten feet away, pulling his bat from the batting rack, when the commotion began. "As soon as that guy came on the field, he was screwed," Boog recalled. "Frank [Robinson] just about knocked him out. Everybody wanted a piece of his ass."

The intruder, later identified as a thirty-four-year-old crane operator from Hammond, Indiana, "paid dearly," Hatter wrote. "He absorbed a bloody beating before his rescue by police and security guards."

The Orioles won that game 11–3 and lodged a complaint with the office of baseball commissioner Joe Cronin about the latest in a rash of knockdown pitches aimed at them. They then proceeded to win 101 games and capture the American League East title by 12 games. Boog snapped out of his slump in late August and was heating up when the Orioles faced the Oakland Athletics in the championship series.

In 1971, Boog also enjoyed a distinction among baseball players: a musical was written about him. Inspired by a photo of Boog at bat that appeared on the cover of *Sports Illustrated* in June, Bob Ottum, a senior editor at the magazine, penned "BOOG!" a work of fiction and comedy that ran in the July 19, 1971 issue. The plot of this would-be production consisted of Boog being kidnapped and replaced by a robot that was manipulated by a mad scientist. Eventually, the real Boog escapes his captors, returns to the ballpark and slugs again. The Baltimore Oriole Chorus sings: "When you need a quick score / Maybe three, maybe four / Who belts 'em I ask you / Who? Boog do."

The musical was aimed, in the words of *Sports Illustrated* publisher J. Richard Munro, at "far, far off Broadway." It did not make it off the pages of the magazine and was never performed.

The Oakland A's team, the Orioles' first opponents in the 1971 post-season, featured an impressive list of pitchers, including Vida Blue, Jim "Catfish" Hunter and Rollie Fingers. But it was a mollusk, a slippery oyster, that almost shut down Boog in the Oakland series. Boog was relaxing at his Medford Road home a few blocks away from Memorial Stadium, savoring the Orioles' 5–3 Game One victory, when a friend dropped by with a couple dozen oysters. "They were gorgeous, a couple dozen Chincoteagues," Boog recalled. "We had a couple of 'soda pops' [beers] as we shucked those oysters and ate them. Then, on the very last oyster, I stuck the oyster knife into my thumb. It was a good one, about an inch and a half in my left hand."

Remembering the time in 1966 he went to an emergency room with a gash in his head and tried to offer an assumed name, Boog knew that a trip to the hospital meant unwanted publicity. So instead of going to a hospital, he rang up a neighbor. "My next-door neighbors were Don and Jackie Hill. He was a pediatrician at [Johns] Hopkins [Hospital], a great guy. I let him look at my thumb, and he said it was pretty bad and would have to be closed up.

"I said, 'Can you do it?' And he said, 'I don't know. All I have are these pediatric needles, and I don't have any novocaine.'"

So, in the Medford Road row house, the massive six-foot-four-inch Orioles first baseman stretched out and offered up his bleeding thumb to a neighbor who was working with short needles made for stitching up small children. It did not go well. Boog recalled, "I lay down, and Don cleaned it out real well, and then bang! The needle breaks. That felt real nice. Then the second needle breaks. Then Don says, 'I have one needle left.' He got it and put in about four stitches."

The second game of the series, with Catfish Hunter on the mound for the A's, beckoned.

"I went to the ballpark," Boog recalled, "and didn't say anything to anybody. That was one of the biggest mistakes I ever made. I had a glove on the whole time. [Trainer] Ralph Salvon says, 'You OK?' And I say, 'Yeah, I'm OK.' After a while, the stitches came loose, and my glove was filling up with blood. Catfish knew I was hurting, so he came after me. He busted me in, and I said to hell with it and made out like I didn't have anything wrong with me." Boog slammed a home run. A subsequent at-bat yielded the same result: a home run.

"I was hurtin'," Boog recalled. "To this day, I don't know how I did it. I was very happy. After the game, I went to Union Memorial [Hospital] and had my thumb done right."

The Orioles swept the A's in three games, an outcome that, according to Boog, was preordained. "We knew we would win," Boog told reporters after the final game. "You get us in a short series with a lot of money on the line, and we are going to play you some baseball."

In the opposing locker room, there was agreement. "We are good," said Reggie Jackson, an Oakland slugger who would later briefly play baseball in Baltimore. "Baltimore is great."

Talk of an Orioles dynasty began. "It is almost time," wrote Wells Twombly, a columnist for the *San Francisco Examiner*, "to start thinking of the Orioles as legitimate heirs to the old Yankee empire."

Heady stuff—but the Pirates soon brought the '71 Orioles back to earth. After losing the first two games to the Orioles, the Pirates rallied behind the .400 hitting and stellar defense of Roberto Clemente and defeated the Birds in seven games.

It was an unhappy World Series for Boog. He collided in Game Five with Elrod Hendricks as the two of them chased a foul pop-up hit by Jose Pagan. Elrod caught the ball; Boog went head over heels. During the series, Manny Sanguillen, by one reporter's count, had stepped on Boog three times as the Pirate catcher navigated the base paths. With his right wrist wrapped and his left thumb recently stitched, Boog hit a lowly .111 for the series.

Yet there was little time for wallowing in defeat. Three days after the series ended, the Orioles, their wives and (thanks to Boog) several cases of Old Forester bourbon were on their way to Japan.

CHAPTER 7
JAPAN

It was the ultimate road trip—a celebratory swing through Japan, where the Orioles were treated like royalty, sated with sake, fed fine cuisine in the clubhouse and served champagne in the dugout.

A broken arm almost kept the Powells grounded. Jan and other Orioles wives were welcome on this trip, so the three Powell kids had to be quickly transported from Baltimore to Florida, where relatives would watch over them. Jan and the girls, Jennifer and Jill, flew down to Miami, and the plan was for Boog and J.W. to follow them south, driving the family car pulling a rented trailer.

Complicating the equation, J.W., then a boy of eight, was running through their Baltimore neighborhood en route to a home to see some ducks, albeit dead ones. "There was a guy down the street who had been hunting," J.W. recalled in an interview. "He had these mallards and was cleaning them."

The alleys behind the houses of Medford Road are a couple steps lower than the backyards, and in his rush to view the ducks, young J.W. tripped and fell on one of those concrete steps, landing on his arm. The arm was broken, but he kept this fact hidden from his dad.

"The Series was over on a Sunday, and I left Baltimore after the game. We were driving to Miami, and J.W. wasn't letting on that he was hurting," Boog recalls. "We got to South Carolina, and I pulled over and slept for an hour or so. Then we drove to Miami and unloaded the trailer, and I noticed he was favoring his arm. So we took him to the doctor; sure enough, he had a broken arm."

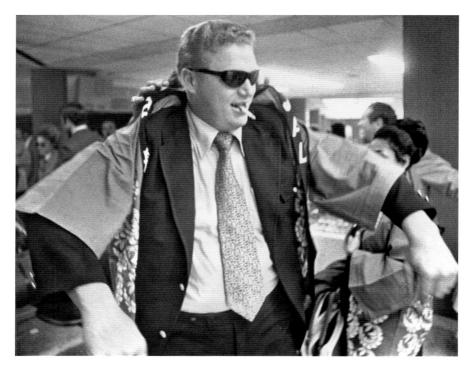

Above: If the kimono fits. Boog getting into the spirit during the Orioles' 1971 tour of Japan. *Reprinted with permission of the Baltimore Sun Media Group. All Rights Reserved.*

Opposite: Boog and Jan before a game in Japan. *Author's collection.*

Early the next morning, it was a hurried goodbye as J.W. (in his new cast) and his sisters were handed over to grandparents. Boog and Jan grabbed an early morning flight out of Miami to rendezvous with the Orioles traveling party that was flying out of Baltimore.

As the Orioles' chartered flight headed west, the fun began. The plane touched down in San Francisco, either to refuel or, in Boog's telling, "because we didn't have any more tomato juice for Bloody Marys."

There was also a layover in Hawaii, where catcher Clay Dalrymple, perhaps feeling the effects of the Bloody Marys, ran down an airport corridor and demonstrated an expert hook slide, landing at the feet of Orioles owner Jerry Hoffberger. "Jerry didn't think that was too funny," Boog recalled.

On arrival in Japan, the Orioles party was squired to the New Otani, a Tokyo hotel that featured sixteen restaurants—and Boog tried almost every

one. "They had every kind of food you can possibly think of," he recalled. "We had pieces of Kobe beef. Back in those days, a steak was about seventy dollars. The beef would be sitting in a cooler, and you would point at the one you wanted and tell them how thick. I had a three-inch-thick ribeye…oh my goodness, it was just like butter. And there was sushi, the best, and shrimp tempura. Man, it was an awesome place."

Boog examines the broken leg of teammate Clay Dalrymple, who recovered and later did a hook slide in the Hawaii airport en route to Japan. *Author's collection.*

It was a whirlwind tour, with the team scheduled to play Japanese teams in eighteen cities. When one game in Sapporo was snowed out, Boog was grateful because, thanks to all the good food and drink, "I am not so sure I could have answered the bell that day."

At the ballparks, the routine was different than back in Baltimore. "There was a champagne cart in the dugout," Boog recalled, "so we would be sipping champagne and eating shrimp tempura during the game." The spread in the clubhouse was also several steps up from the usual locker room fare at Memorial Stadium. "In the locker room, food was served on china," recalled Boog's teammate and fellow traveler Merv Rettenmund.

Boog's on-field duties were pretty light. "Brooks, Frank and I only got two at bats," he recalled. "We would only hit twice in each of the towns, and then Earl would say, 'Get out of here.' We would go back to the hotel, change out of our uniforms and set them outside the hotel room door. Then we would take a shower and then sit around for a while and maybe

The Orioles traveling party at Hiroshima Memorial in 1971; Boog and Frank Robinson are front and center. *Author's collection.*

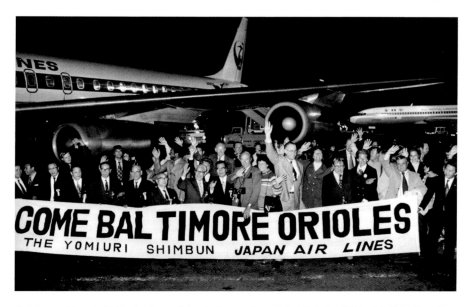

Orioles and baseball dignitaries arriving in Japan. Boog is behind the "L" in "Orioles," while baseball commissioner Bowie Kuhn is behind the first "O." *Author's collection.*

have a drink. Then, within an hour, our uniforms would be back, neatly folded and pressed."

The team traveled around Japan by train. In Hiroshima, their reception at the ballpark was cooler than in other cities, but the post-game party was exceptional. "It was the most elegant party I have ever been to," Boog recalled. "Brooksie and I carried a keg of sake on two wooden poles into the gathering." Then, Boog raised a mallet and tapped the keg of sake—a ritual he would be called upon years later to repeat at the ceremonial tapping of the keg of beer to begin Baltimore Beer Week in 2009. "We cracked that keg, dipped a ladle in and sipped one-hundred-year-old sake. They also served us raw quail eggs; man, they were wonderful."

At the time, bourbon was hard to get in Japan, but thanks to Boog's connection with Churchill Distributors in Baltimore, the Orioles traveling party was rarely wanting. Forewarned of a potential bourbon shortage in Japan, Boog agreed to an offer made by a representative of Brown Foreman to watch over a shipment of bourbon to Japan that would keep the Orioles group in brown goods.

"When we got to Tokyo, there were thirty cases of Old Forester [bourbon] waiting in the lobby," Boog recalled. "The hotel staff said, 'Mr. Powell, we cannot put all these in your room.' I said, 'OK. To lighten the load, give everybody in the traveling party at least one bottle.' So everybody got a bottle, and we still had about eighty bottles, so we took them back to our room and had the bourbon sitting up there."

The bourbon, Boog soon discovered, made him welcome at many venues and helped him get a seat on a crowded train. "It was a trip to Kyoto, and [Orioles pitcher] Pat Dobson and I were trying to find a place to sit down, but the train was packed. We walked past the dining car, and the kitchen was there. We looked in, bowing to all the guys working there, and I opened my coat and showed them a bottle of Old Forester. And they all said, 'Ahhhhhh.' So we gave all the cooks a glassful. Then one of the fellas asked us, 'You want to sit down?' And we nodded, so he moved people out and we sat down in the dining car."

But the adventure in the dining car was just the beginning. Next came a visit from a Japanese sportswriter and a liquid, cross-cultural challenge. "The writer comes up and pours me a shot of sake," recalled Boog. "And one of the interpreters tells me, 'He is going to be insulted if you don't drink it.' So I said OK and fired it down. Then the interpreter tells me that if I don't pour the guy a drink now, he is going to be insulted. Two bottles of sake later, this writer takes off running through the train and dives onto the

Oh my! Boog feeling the muscle of Japanese slugger Sadaharu Oh. *Author's collection.*

lap of Earl Weaver, who was reading a newspaper. Earl had him thrown off the train at the next stop."

By the end of the two-week excursion, some of the players had spent their allotment of 300,000 yen (roughly $1,500) and had to get creative to come up with spending money. One fellow in need of cash was Dobson, who sold Boog a camera.

The camera came with a story. "The Japanese gave us presents," Boog recalled. "Dave McNally pitched a pretty good game somewhere, and a representative from Canon gave him a $700 camera. Then Pat Dobson pitched a no-hitter, and he didn't get anything. So Dobson complained, and the next day he got a $700 camera. He ended up selling it to me because he ran out of money.

"He said, 'Gimme a hundred dollars for the camera.' I said, 'What are you talking about?' He said, 'I don't have any money.' So I reached down and gave him a hundred. I told him, 'If you want the camera back, I will give it to you for a hundred.' But he never wanted it back. I ended up

taking time-lapse photographs on the trip back home of the sun going up and going down."

After a month of such indulgence, Boog and the rest of the Orioles returned to Baltimore. They had played eighteen games in fourteen cities, winning twelve, losing two and tying four. "It was the time of our lives, " Boog recalled, "but we were sure glad to get home. I was wore out and looked like a beached whale. Brooksie looked like a toad frog."

When Andy Etchebarren asked Boog how much he thought he weighed after the visit to Japan, Boog told him, "Somewhere between three and four."

It might have been coincidence, but the next season, Orioles management cut back on the cold cuts traditionally served in the clubhouse and ordered more slimming fare, like cottage cheese.

CHAPTER 8
DAYS OF DISAPPOINTMENT

It was the season of the hangover. After a boisterous tour of Japan at the end of 1971, the Orioles—perennial American League East victors—were logy in 1972.

The club stopped hitting. Boog struggled early, and by midsummer, when he rebounded, it was too late to catch the Tigers. The Orioles finished third behind Detroit and Boston. Detroit took the title in the East before losing to Oakland, the eventual World Series champions.

The 1972 season began with a cottage cheese kerfuffle. In an effort to get the players more health conscious, Orioles management cut down on the sandwiches served in the locker room and replaced them with cottage cheese. It did not go over well. Players balked at the curd in their clubhouse. Boog dismissed the offering as the work of "some health nut."

When the change in clubhouse diet did not produce wins, Orioles manager Earl Weaver changed tactics, dropping asides to sportswriters. "We miss Boog Powell," Weaver told scribes in early June when the first baseman was batting below .200. Boog was not the only Oriole swinging and missing. In another chat with reporters in late June, Weaver noted that Don Baylor, Bobby Grinch and Terry Crowley were hitting but that the three "Bs"—Buford, Brooks and Boog—were not.

Boog was so frustrated that he tried wearing glasses. Vision in his left eye was 20/30, plenty good to pass a driver's license test but perhaps not good enough to catch up with a fastball.

The "specs" were a disaster. They took several weeks to get to him as he traveled with the team. When they finally arrived, the team was on the West Coast, and he quickly discarded them. They made him dizzy, and they fogged up. He was hitting .152.

Time heals most things, and in Boog's case, it healed his swing. After going hitless in eighteen at-bats, he ignited in late July, getting ten hits in twenty-four trips to the plate. One of the victims of Boog's resurgence, Detroit pitcher Bill Slayback, summed up the situation this way: "Powell looks nice, and then he takes that big swing and ruins you."

A late-season surge—hitting at a .297 clip and knocking in sixteen home runs—helped boost Boog's statistics, but he finished the season at .252 with his home run and RBI numbers (twenty-one and eighty-one, respectively) lower than in the previous campaign.

Once again, the issue of Boog's weight made news, with Orioles management telling the *Sun*'s Lou Hatter, "Boog is too heavy." His teammate Jim Palmer resurrected it in January 1973, stating that there was "no question that too much weight hurt Boog last season."

This time around, Boog dealt with the question of his size by going large. He embraced his size and gave a big-hearted welcome to a *Sports Illustrated* writer, a not-so-svelte three-hundred-pounder named J.D. Reed, who was working on a piece about fat celebrity athletes. Reed was drawn to Boog, he wrote, after watching him play on television.

"The American League's Most Valuable Player comes to the plate," Reed wrote. "My God! There is a bowling ball under his shirt! This guy is fat, and he is the best! Pass the chips and dip, please. Boog Powell knocks in two runs and lumps around third base. Something in you has taken pride, you undo the top button of your slacks. Everything is going to be all right."

Reed flew to Miami to see Boog. "He had an unlimited expense account," Boog recalled, "and we tested it." After a spring training game, Reed took Boog and Jan to dinner at a restaurant that was so French that the writer suspected that the "onion soup would be served in berets." They dined on snails in butter and garlic sauce, Caesar salad, steak Diane, a filet stuffed with truffles and mushrooms flambéed with brandy. Boog thoroughly enjoyed himself. He sang a country-western song, "Hello Walls," during the appetizer course. The waiter introduced himself as "Henri," but Boog called him "Hank." In between courses, Boog recounted the battles he had fought over his bulge. He reported that he weighed 252 at the time but had weighed as much as 290 at other points in his career. He told of wearing rubber suits and of that visit to the psychologist who, in a discussion of why Boog liked

to eat, pulled out pieces of rubber food. Boog said he headed for the door when a rubber BLT appeared.

After the repast at the French restaurant, the trio repaired to the Powell home for coffee and more country-western music. Then Boog and the writer roared into a truck stop for breakfast. There, they feasted on fried eggs, a double order of sausage, toast, orange juice, hash browns and pancakes. The writer, who had stayed up all night, eventually got a plane. Armed with bottles of Pepto Bismol, he went on to interview 450-pound Olympic weight lifter Chris Taylor in Iowa and twenty-two-game winner, 220-pound Detroit Tiger pitcher Mickey Lolich in New York.

Back in Miami, Boog, who also had not slept, went to the ballpark. There, during a pre-season game against the Yankees, he ran wind sprints in the outfield and then got two hits and batted in two runs. All in a day's work for the big fellow.

Months later, an account of Reed's visit with Boog ran in an article entitled "Always Ready to Chew the Fat." The July 16 issue featured a photo of Boog ready to dig into a mammoth lobster at Jimmy's Harbor Side Restaurant in Boston. Actually, Boog couldn't polish off the ten-pound lobster, but Jan and trainer Ralph Salvon pitched in to do the deed.

The magazine piece was mostly complimentary to Boog, pointing out that while he once bordered on being fat, he had "melted away to average size." By employing his welcoming manner and sense of humor, Boog seemed to have turned the issue of his weight to his advantage.

His *Sports Illustrated* publicity did not, however, help him on the ball field. During the 1973 season, writers for the *Sporting News* wondered if Boog was "washed up." Hampered by a sore shoulder and diminished playing time, he ended the season with only eleven home runs and fifty-four runs batted in. In the off-season, the Orioles offered him up for a trade but got no satisfactory offers.

The 1974 season began with more trade rumors and a salary cut from about $92,000 to $75,000. Sportswriters, hitting a different tone on an old tune, noted that Boog's weight was down to 250, but so was his batting average. He was not playing regularly and was unhappy, but he bore his burden quietly. "I know he is mad at me," Orioles manager Weaver told Jerome Holtzman of the *Chicago Sun-Times*, "because he is not playing every day, but he is too nice a guy to say anything. He wouldn't do anything to disrupt the club."

"What good would it have done?" Boog recalled years later. "Earl hit me ninth one time that year—that got to me more than anything. You know, a

Plaid airborne Birds. Boog (sipping coffee) at the Baltimore airport with 1974 teammates Don Hood, Bobby Grich, Ross Grimsley, Frank Baker, Doyle Alexander, Bob Reynolds and Wayne Garland. *Reprinted with permission of the Baltimore Sun Media Group. All rights reserved.*

club puts you out on waivers all the time, more times than we ever would know." (A waiver is a procedure that allows baseball owners to test other teams' interest in a player. If the interest isn't there or the proposed deal isn't attractive to the owner, the waiver is withdrawn.)

In early October, Boog came off the bench and was on fire. He led the Orioles assault on the Yankees and Red Sox. Down the stretch, he hit a solo home run to defeat the Indians 3–2. His pinch-hit single to left center in a seventeen-inning game against the Yankees became the deciding run in another 3–2 win, and later in Boston, his seventh-inning home run became the deciding run in a 2–1 win. "Boog has come through like gangbusters," Weaver told the *Sporting News*. Once again, the Orioles had won the American League East, this time finishing two games ahead of New York.

But the victory was short-lived. The world champion Oakland Athletes handled the Orioles in four games in the championship series and then went on to beat the Los Angeles Dodgers to earn back-to-back titles.

Boog had only one hit in the Oakland series, but his RBI single in the ninth of Game Four broke a string of over twenty scoreless innings for the Orioles.

Yet trade rumors swirled. The *Sporting News* referred to Boog as "extra bird baggage," and in February, after fourteen years with the Orioles, he was traded, along with Don Hood, to the Cleveland Indians for Dave

Boog's backyard in Towson. J.W., glove in hand, gets his younger sister, Jill, ready to watch their dad play. Boog with Jill and his prized tomato plants. *Author's collection.*

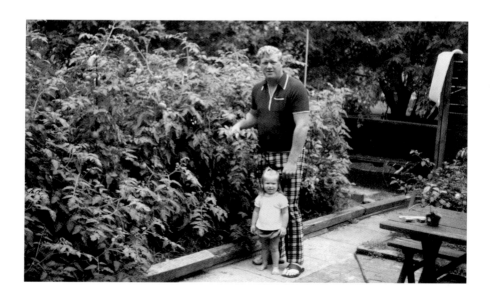

Duncan and Al McGrew. Jerry Hoffberger, the Orioles majority owner, telephoned Boog to tell him of the trade. "He thanked me for all I had done. His voice was quivering," Boog recalled. "It was a class act. People have no idea how disappointed I was to leave. I had bought two homes here, had been a part of the business community and had been to Colt games, Bullet games and concerts down at the Civic Center to see Johnny Cash, Roy Clark and Willie Nelson."

The Powells eventually put their house in suburban Putty Hill, where they had lived since 1971, on the market. It had been a good home for them, and since it sat at the end of a series of row houses, it had a roomy backyard. Boog had enjoyed the backyard as well, growing towering Better Boy tomato plants, entertaining teammates and cooking late into the night. "I would make this big roast," Boog recalled, "marinating it in all kinds of vegetables. Then I would put it on the grill and get that crust just right and the middle medium rare. Man, people went crazy for that."

The only drawback of the house, Boog said, was that it overlooked the athletic field of Calvert Hall High School. The band would practice on those fields early in the morning—much too early, Boog recalled, for a fellow who had been up late. "That Calvert Hall band would start practicing at seven in the morning after I had been up past midnight after a night game. Man, that was rough."

Merv Rettenmund was a regular at Boog's gatherings. "We would never eat until at least two in the morning," he recalled in an interview. "His backyard, even in a row home, was filled with tomatoes and peppers. That was his hobby—eating and drinking."

Boog looked forward to playing in Cleveland. His former teammate Frank Robinson was the manager there. Moreover, the fences were not so far away.

CHAPTER 9
OFF TO CLEVELAND AND LOS ANGELES

Boog arrived in Cleveland in 1975 with a positive attitude and a rehabilitated shoulder.

His right shoulder had been the source of excruciating pain, so much so that he ended up throwing baseballs underhand. The cause, he said, was a combination of things: years of throwing, years of wear and tear.

In Baltimore, he had tried a variety of remedies for the shoulder, but none worked. "I was doing rehab, special weight training. It never got better," Boog recalled. He tried painkillers as well. "They would shoot me, but it never felt any better."

Then, in the winter of '75, he met a physician down in Miami who had several jai alai players as patients. The doctor told him that jai alai players, who wield oblong baskets to send a goatskin ball off granite walls, have a lot of shoulder problems. The doctor said he had used a treatment that gave the jai alai players some relief. The treatment involved a sending a long spinal needle through the chest and then down to a selected spot in the shoulder, where a dose of novocaine would be delivered from a syringe at the opposite end of the needle. Boog gave it a try. "It hurt more than anything I had had in my life," Boog recalled. Then, when the novocaine was delivered, the pain was gone. "The doctor said if he had hit the right spot, my shoulder would improve," Boog said. The doctor had hit the spot—and Boog began hitting the cover off the baseball. That season, he hit .297, drove in eighty-six runs and socked twenty-seven home runs.

In addition to playing with a rejuvenated shoulder, Boog liked the confines of Cleveland's Municipal Stadium. The power alleys of right center and left center field were a few feet longer than those in Baltimore. But the six-foot fence was eight feet shorter than the one in Baltimore, dimensions dear to a home run hitter's heart.

"It was a fair ballpark," Boog said of the Cleveland stadium. "I hit some home runs there that wouldn't have gone out in Baltimore. In Baltimore, right center and left center would eat you alive. The ball just didn't carry there."

Boog also fit in with the character of the Cleveland team, big guys who swung big bats. "We had Duane Kuiper, Buddy Bell, Frank Duffy, Rico Carty, Charley Spikes and George Hendricks—man, what a great hitter he was. We didn't have much pitching, but we could score some runs, an average of six or seven runs a game."

His affable personality combined with his slugging made him popular with his Indian teammates. When Bell was nominated for the All-Star Game in '75, he turned down the invitation and said his teammates Boog and George Hendricks should be sent to the game. It didn't work out that way, but Boog was later named Comeback Player of the Year, an honor that touched him, especially after the down years in Baltimore. Telling the *Sporting News* that he took a sense of pride in his comeback, Boog added that in the prior year, "I was the only one in Baltimore who thought I could still play."

His new skipper and former Orioles teammate, Frank Robinson, echoed the theme of Boog's redemption. "Boog had a great year," he said, "and that was very satisfying to me because last winter everybody said he was through."

The Indians didn't win the American League East that year, but neither did the Orioles; they couldn't catch the Boston Red Sox, who finished four and a half games ahead of Baltimore.

Boog couldn't resist needling his former skipper, Earl Weaver, and coach Billy Hunter about what might have been. "I ran into them in a bar," Boog said, "and told them, 'If you had me right now instead of Enos Cabell, you would be going to another World Series.'"

Boog's rebound was also noted and appreciated by baseball fans living far away from Cleveland. "This friendly giant always has been a professional in every sense of the word," wrote Richard Ruggeri of Poughkeepsie, New York, in a letter published in the *Sporting News* on September 13. "It is good to see him doing well again and receiving recognition for it."

Another benefit of becoming an Indian was developing a friendship with Herb Score, the one-time power pitcher who had become a Cleveland broadcaster. "Herb Score was one of my idols," Boog said. "He was from Lake Worth

[Florida], and when I was a sophomore in Lakeland High School, he beat us. Nobody could hit him."

Score signed with the Indians at the age of nineteen and was a terror on the mound early in his career, with a blazing fastball. "Then Gil McDougald hit that line drive off his eye," Boog recalled, referring to an injury suffered in a May 7, 1957 game against the Yankees. "He was never the same after that; he threw breaking balls."

When Boog landed in Cleveland, the two former high school rivals became friends. "We were both Florida boys and hit it off," Boog said.

After being reunited in Cleveland with Frank Robinson, Boog was named the *Sporting News* Comeback Player of the Year in 1975. *Author's collection.*

The Powells now resided in Key West, Florida, having moved there in 1975. J.W. and Jennifer enrolled in Key West High School, the same school that their father had attended decades earlier. They, like their dad, played on the school's sports teams, proud members of the Fighting Conchs. "I graduated from that school twenty-five years after my dad," Jennifer said. "But I was a 'fresh-water conch' because I wasn't born there."

The glow of good feeling from the 1975 season was apparent in the reports coming out of the Indians '76 spring training camp. "Boog doesn't exactly look skinny," skipper Robinson said, remarking on the fact that Boog had shown up at camp ten pounds lighter than the previous year. "But he looks like a different 257 pounds."

Boog's off-season training regimen, one that he had developed over the year, had new meaning. "I would squeeze a half a tennis ball all winter to strengthen my hands and wrists," Boog recalled. "I set up a rubber tee, put a ball on it and took swing after swing, really concentrating on driving through

the ball. I would take a piece of rebar, hold it over my shoulders and swing it repeatedly. Then I would do curls with it. I would run four or five miles, mixing in about twenty hundred-yard sprints."

He had gone to bat 435 times last season, and in the coming year, he wanted to up that total by 100, he told reporters.

It was not to be. Early in May, his name was on the All-Star ballot, but a string of injuries laid him low. He sprained his ankle in an April 25 mêlée. He tore his right thigh.

Standing at the plate, he still was a formidable presence. "Boog puts pressure on a pitcher in a close game," Minnesota reliever Bill Campbell remarked. But he played in only ninety-five games, hit a career-low .215 and finished a disappointing year with nine home runs and just thirty-three runs batted in.

Searching for more power from their first baseman, the Indians signed Andre Thornton and released Boog in the first week of April, just before the 1977 season began.

The Los Angeles Dodgers picked him up as a backup for their first baseman, Steve Garvey. He got a warm reception in Los Angeles, even if he did not play much. "In less than a year, Powell has become one of the most popular Dodgers," wrote Los Angeles–area sportswriter Gordon Verrell. "He gets a walk, then trots off for a pinch-runner to a standing ovation."

He also impressed a few of his younger teammates with his strength. One day on the road, Dodgers Ed Goodson and Mike Garman were horsing around on a bed in a hotel room shared with Boog. Boog had enough of their antics, and to the amazement of Goodson and Garman, he lifted the bed and ballplayers up and flipped them onto the floor.

Overall, he was warmly received in Los Angeles. "The fans respected me for what I had done in my career," Boog recalled. "They did not forget the 1966 World Series."

Still, he struggled. "I went to see him when he was with the Dodgers," Merv Rettenmund, Boog's former teammate, recalled in a telephone interview from his San Diego home. "He was having a hard time. He was a great hitter, but he didn't have the swing for a part-time player. He had a lot of moving parts, and it is tough to get your timing when you are a utility player."

The Dodgers were managed by Tommy Lasorda, who, Boog recalled, knew his way around Italian food. When the Dodgers were in Philadelphia, Boog said, the team would be bused to the Italian restaurant favored by Vince Piazza, father of future catching star Mike Piazza and Lasorda's longtime buddy.

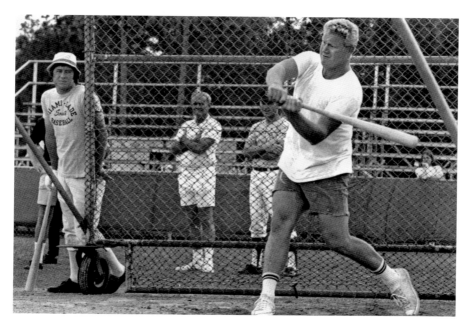

Boog built on the spring training workouts of his earlier years, such as this 1970 batting session at Dade Junior College with New York Yankee Bobby Murcer. *Author's collection.*

It was Lasorda who gave Boog the news, in late August 1977—shortly after Boog's thirty-sixth birthday—that his brief days with the Dodgers were finished. Lasorda told him that releasing him was one of the toughest things he had ever had to do. Boog replied, "Tommy, let me make it easy for you."

Rather than being depressed, Boog was elated by the development. "That was one of the happiest days of my life," he recalls. "I was so tired of sitting on the bench."

After saying farewell to his teammates—and, as it turned out, to the major leagues—Boog bought a van, gathered his family and took another journey. This one would both take him across the country—from California to Florida—and to new occupations: owner of a marina and a Miller Lite television celebrity.

LIFE AFTER BASEBALL

L ife without baseball can be rocky for retired players. The limelight, the recognition, the special treatment and the camaraderie of teammates are suddenly gone. Then there is the matter of making a living.

Boog felt he was prepared for the next phase of his life after he hung up his spikes in September 1977. He was and he wasn't.

He had begun thinking about life after baseball even while he was still in the game, shuffling his real estate. He had moved out of his house in Towson after getting traded from Baltimore to Cleveland in 1974, renting it out for a few years before eventually selling it. He bought property in Key West in 1975 and in addition had homes in Miami and the North Carolina mountains.

Plotting his post-baseball career, Boog talked at length with Charlie Lau, who in addition to being a highly regarded hitting instructor was Boog's former Oriole teammate and a treasured friend. Boog was upset when the Orioles let Lau go in 1967.

Boog valued Lau's advice on both the physical aspects of hitting, such as having the bat in the launching position as soon as the front foot touches down, and the mental aspects, such as knowing what the pitcher was likely to throw in certain situations. .

A skilled fisherman, Lau shared many nautical adventures with Boog, such as the time they led two boatloads of spring training Orioles to an island off the Florida coast to harvest spiny lobsters at night. "Boog knew the guy who ran the lighthouse," Eddie Fisher, one of Orioles on the outing,

Boog, a man of leisure, fishes at his Key West marina. *Author's collection.*

recalled. "Boog and Charlie were good divers; they would dive down, get these Florida lobsters and throw them up to us. We boiled them and had a heck of feast."

Boog and Charlie mulled over memories of this and other watery experiences as they considered various ways Boog could make a living after baseball. Some conventional land-based jobs, like selling insurance, were considered but tossed aside. A neighbor who was an insurance executive had told Boog he could "write his own ticket" as an insurance salesman, but Boog demurred. "That did not sound like me," he recalled.

What did sound like him, a man familiar with ocean salt and spray, was owning a marina. "Charlie and I were talking one day," Boog recalled, "and the marina idea just rang a bell. It seemed like a good idea. We started aiming that way, and this deal came open on a marina down here in Key West. We bought it a good price."

His lawyers had recommended against the purchase because at the time, 1975, he was still playing baseball, meaning that for large stretches of the year, he would be an absentee owner. But Lau, Boog and Jan felt it would be a good

way for Boog to do what he enjoyed: boating and fishing. This was, after all, a fellow who as a boy used to amuse himself by riding his bicycle into lakes.

Things went well for a time. Reporters penned pieces about Boog's successful new venture. "Huckleberry Finn has nothing on me," he told a *Sporting News* reporter who spent a day in 1982 bobbing in the Gulf of Mexico with Boog. His brother, Richard, ran the bar at the marina and became well known for making a mean bowl of chili. Boaters who floated in for fishing tournaments were often treated to Boog's barbecue. One of his favorite offerings was a whole pig cooked in what Boog called a "Cuban microwave." This device, employed by former residents of Cuba, consisted of placing a whole pig, sometimes doused with the juice of sour oranges but always liberally seasoned, in a wooden box lined with metal. A tray holding hot coals was placed atop the pig, and then the box top was closed. The pig cooked relatively quickly, and the skin was crackling and crisp.

"They tore it up," Boog said of his smoked pig.

Another menu item that was a hit with the boating crowd was fried cobia. This silvery fish, a crab eater, has sweet flesh. "We would catch them, cut them in same-size fillets and freeze them. And when we had a big event, say feeding four hundred, we would cook them in corn oil," Boog recalled.

Thanks to good eats and a good economy, the marina did well for several years. Son J.W. helped run the bait and gas side of the business. Daughters Jennifer and Jill helped their mother, Jan, run her nearby women's clothing store, JP's of The Keys. Then fuel prices spiked, the economy soured and boats became too much of an economic burden for many weekend captains. In addition, Boog was often away selling beer for Miller Lite. When he was around, he had trouble saying "no" to suppliers, and his expenses multiplied. Business debt mounted, and after waiting for a rebound that never came, the marina was sold at auction in 1988.

Being a successful marina owner requires devoting ungodly hours to the enterprise, according to Jim Halloran. Halloran sold Boog the marina, and the business transaction evolved into a friendship between Halloran and his wife, Pat, and the Powell family. The families saw each other socially, even after the Hallorans moved from Key West to the small town of Hayesville in the mountains of western North Carolina. There, Jim, Boog and J.W. would fish for native trout in the mountain streams, cook the fish over a campfire in near-freezing conditions, push their pickup truck out of snow banks and then repeat the ritual the following year.

From this perspective of companionship and shared business experience, Halloran ascribes the unhappy end of Boog's marina ownership to Boog's

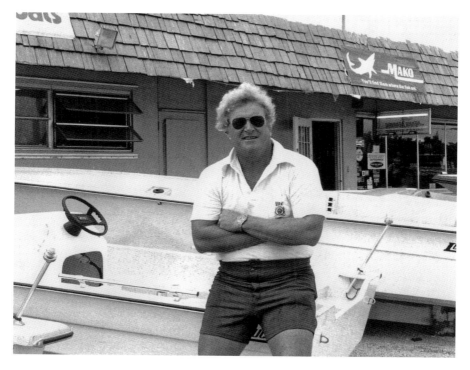

Boog outside his Key West marina, which was sold at auction in 1988. *Author's collection.*

absence. "Boog loved the water and loved the fishing and loved the bullshit that goes with the marina. But it is a labor-intensive job. When I owned the marina for the first four years, I opened at six in the morning and closed at midnight, seven days a week. The problem Boog had was that he had so much going on besides that that he couldn't sit on top of the marina. He was out making money, good money, with Miller."

Looking back on the experience, Boog said, "I learned that there is a lot more to running a marina than boating and fishing. It is a business, a tough business that required more of my time than I could give it."

Meanwhile, he had another job, one that fit his personality and skill set: being a regular performer in Miller Lite beer commercials. He happened on this line of work shortly after he was released by the Dodgers in 1977.

He and his family were ambling their way back to Florida from California, and he was adjusting to his new daily routine. At one stop along the way, he got up from an afternoon nap and started to head out the door. When his wife asked where he was going, he replied, "To the ballpark." She gently

reminded him he was no longer playing baseball. "When you do something for that long, it is hard to change," Boog recalled.

At another stop on the journey, he turned on the television in a hotel room, and up popped the image of Marv Throneberry, the bumbling former New York Mets first baseman. Throneberry appeared on the screen in a Miller Lite ad, exclaiming, "I can't believe they wanted me to do a commercial."

"I can do that, or do whatever Marv did," Boog recalled thinking. He started making phone calls. Eventually, he reached Marty Blackman, a New York attorney who was working with Miller Lite on the commercials. When Boog told him he wanted to do one of those Miller Lite commercials, Blackman laughed. He already had Boog on his radar. "I was waiting for him to retire," Blackman told the *Sun*'s John Eisenberg in 1986.

Boog went to New York to try out and breezed through the script reading. He was a natural, projecting an easygoing, down-home sense of humor. He was, in short, a guy you wanted to have a beer with.

In his first commercial, Boog was paired with retired American League umpire Jim Honochick. The initial takes of the commercial were not going well, Boog recalled, until he coaxed the ump into enjoying a liquid lunch. "The first shoot was going very slowly," Boog recalled. "You know, they have to work on the lighting and the sound. You think the retake is something you did, but no, it is the lighting and the sound. I knew some of this, but it was bothering Jim. He was nervous. We broke for lunch, and at lunch I said to Jim, 'Let's have a martini.' We did, and we came back from lunch and boom! boom! boom! We knocked out that commercial. The director said, 'It can't get any better than that.'"

Their commercial would become one of the most popular in the Miller Lite Series. In it, Honochick pretended he couldn't see until Boog gave him glasses, and the former umpire, who had been sitting next to Boog for the entire commercial, suddenly blurted out, "Hey, you're Boog Powell!"

The commercial was so successful that Miller Lite ordered up a sequel. While Boog appeared in fourteen other Miller Lite ads, the one with the "blind" umpire generated the most reaction. "People would come up to me in airports, take off their glasses and say, 'Hey, you're Boog Powell,'" Boog recalled.

Moreover, thanks to the commercials, he was now a celebrity, somebody people felt they should recognize. "Some people thought I played football because I was the right size. They didn't quite know who I was, but they knew I was somebody," Boog recalled.

Boog (top left) with the Miller Lite All-Stars at their reunion. *Author's collection.*

Far from fleeting, his fame is now being resurrected, thanks to YouTube. He recounted what happened at an appearance in early 2014 at Baltimore's Power Plant Live—a collection of bars and restaurants near Baltimore's Inner Harbor—where the old Miller Lite commercials were shown to an audience of college-age imbibers. "The kids didn't know who the other guys in the commercials were, but they knew who I was," said Boog.

As part of the deal with the brewery, Boog and the other former athletes known as the Miller-Lite All Stars also agreed to make at least two promotional appearances for the brewery. These appearances ranged from being in a parade, to appearing at a bar, to visiting retail stores. Boog thrived on these outings and was regarded by Miller Lite executives as a "road warrior," a man who would make between fifty and eighty appearances a year for about ten years.

Some of the work was similar to the rounds he made back on Belair Road in Baltimore as a representative for Churchill Distributors. He walked into bars and liquor stores, said hello, shook hands and signed autographs. He had a personality that one beer executive described as "beery."

Other venues were more challenging. Clad in a papier-mâché beer can, he was riding a float in a Mardi Gras parade in New Orleans when a storm hit and destroyed the costume, covering him with the beer can remains.

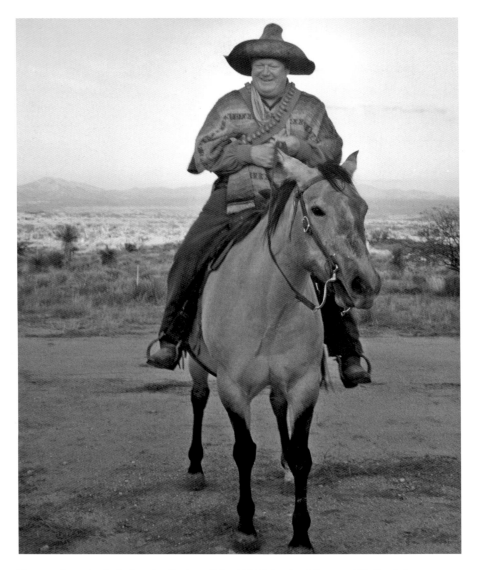

Boog on horseback during the filming of the 1992 Maryland Lottery "El Gordo" commercials. *Author's collection.*

"That was quite a day; we tossed out coins with our image on them. Women wanting coins would take their shirts off." He also appeared with a woman in Idaho and signed her ample bosom with not just with his name but also the Gettysburg Address.

Then there were the bull rides. Boog and Jim Shoulders, a professional bull rider, would appear at bars accompanied by a large, one-horned Brahma bull called Buford T. Lite. "I would go in the bar and get a nice-looking woman to agree to ride the bull," Boog recalled. "Then we would go outside, get her on the bull and make an entrance into the place."

The bull, a veteran of such maneuvers, was docile. But once on the outskirts of Dallas, Buford the bull and Boog got in a slippery situation. "Buford got out on the dance floor, and there was sand on it," Boog recalled. "Buford couldn't get his feet, so he started falling sideways. Jim hollered at me, 'Come on! We gotta keep him up.' So we got into his flanks, pushing him—and that is about 2,500 pounds of bull—until we got him on some carpet." That ended Buford's days on the dance floor.

Boog was paid about $2,500 a day for these appearances, but the travel and the blitzkrieg-like tour of establishments took a toll. "My routine was to take just a sip of beer at each stop," Boog recalled. "But when you stop at a half dozen places, that adds up."

The travel for the beer work, Boog said, was worse than baseball travel. With baseball, he stayed in each city several days at a time. With Miller Lite work, he often hit multiple cities in a day or two. For about two hundred days of the year, he was traveling for the brewery.

The commercials for Miller Lite ended in 1989 after an eleven-year run, although Boog made subsequent appearances from 1990 to 1992 for Miller distributors.

Closer to home in 1992, he appeared in Maryland State Lottery commercials promoting "El Gordo" (which translates to "The Fat One"), a month-long game modeled after the Spanish lottery. Boog became the personification of El Gordo, sitting on a horse and donning a spaghetti western outfit complete with crossed bandoleers, a serape and a crumpled cowboy hat. "They told me it was the same serape Clint Eastwood wore when he made *Fistful of Dollars*," Boog recalled.

"Boog had an amazing on-camera comedic presence," recalled Allan Charles, chairman and creative director of TBC Inc., the Baltimore-based agency that put the commercials together.

Another line of work was about to appear on the horizon: cooking barbecue and selling it at a new ballpark, Oriole Park at Camden Yards. But first he had to say farewell to an old companion: Memorial Stadium. The old park had not always been kind to Boog. Its high fences and distant power alleys, where fly balls tended to die, had cut into his home run totals. When he hit 39 home runs in 1964, his wife, Jan, had counted a least a

dozen would-be homers during the season that died on the warning track. His teammates Brooks Robinson, Merv Rettenmund and Andy Etchebarren said that if Boog had played in almost any other ballpark, especially one with the friendly alleys like those at Camden Yards, he would have hit 50 home runs a year. In his career, he hit more home runs, 206, in other parks than the 133 he hit in Memorial Stadium.

But even if Memorial Stadium had not always been friendly to Boog, it had been familiar. It had its flaws, including rats he once described as "big enough to screw a turkey." They resided in the tarpaulin and took cover in a drainpipe when the tarp was rolled out to cover the infield.

Memorial Stadium had been his neighbor when his family lived, as he liked to say, "just beyond the right-field wall." It had been the site of his triumphs, where he and his teammates won the World Series both in 1966 and 1970. It was where he and fellow players would gab for hours after a game, infuriating their wives, who were waiting for them outside the locker room. It was where Ernie Tyler, the ever-resourceful clubhouse manager, had saved Boog by aiming a can of bug spray on a cluster of bees that had attacked Boog one night just as he had stepped into the batter's box. It was where, much to the chagrin of their teammates, Boog and Charlie Lau had cleaned fish in the locker room shower.

The old ball park was far from an architectural marvel, recalls Jim Henneman, who grew up on Yolanda Road within walking distance of the stadium, who worked as a stadium usher and who later covered the Orioles for the *Evening Sun*. "There were a ton of bad seats," he said. "But what made the stadium exceptional was what happened on the field. Great things happened in that stadium."

The "Old Grey Lady on 33rd Street" was playing host one last time, in October 1991, to the Orioles, and Boog was among the alumni who had gathered to say goodbye.

The last game of season had ended with the Orioles' ninety-fifth loss of the 1991 campaign. Then, in a ceremony that had made hardened men choke up, the field was cleared, and music from the film *Field of Dreams* came spilling out of the stadium speakers. In the fading afternoon light, the Orioles legends trotted out to their old positions, wearing their old uniforms. First to emerge was No. 5, Brooks Robinson. He jogged to third base as the capacity crowd of fifty thousand hollered his name. Next came Frank Robinson, who sauntered to right field, and the fans in the right-field stands stood as they always did for No. 20.

Then the Old Grey Lady shook as the crowd saw an image on the Diamond Vision screen and a stadium packed full of memories hollered,

"Boooooog!" The big, blond slugger ambled toward first base, took off his cap and waved it to the crowd. "I went out there and didn't know how to act; I didn't know what to do," Boog said years later. "I looked over to third, and there was Brooksie kicking the dirt like he always did. He looked pretty comfortable, so I started kicking the dirt. Those first three introductions were special. I will never forget that. I was very moved."

As more former Orioles jogged out of the dugout—Jim Palmer to the mound, Rick Dempsey to the plate and, finally, Earl Weaver to second base—the cheers cascaded, washing the old stadium with an ocean of noise and sentiment. "There were so many of the people from my past who I was so glad to see," Boog said. "It felt like we should play some ball, and we probably could have kicked some butt."

Then "Auld Lang Syne" was played over the speakers. Everybody sang, and lots of tough old characters wept, even Weaver. "I was pushing back tears," Boog said. "We all were."

Home plate had been unearthed from Memorial Stadium and carried in a limo down to the new ballpark—one that would soon make the whole country sit up and take notice. There, Boog would soon set up his pit beef stand. Not only would this be a success in Baltimore; it was a concept that would be copied at ballparks throughout America.

Boog had hatched the idea for this smoky enterprise one night at "the nineteenth hole" of Turf Valley, a Baltimore-area golf course.

CHAPTER 11
THE PIT BEEF BONANZA

Before the first pitch is thrown at Oriole Park at Camden Yards, the lines begin to form at Boog's BBQ. There are two lines. One is for customers who hunger for a sandwich—pit beef, pork or turkey—and the other is for fans who want to meet the man, Boog Powell. He is blond, his skin a bright red from hours spent boating and crabbing on the Chesapeake Bay. And he is enormous. He folds his six-foot-four, 280-pound frame onto a stool, and night after night signs autographs, poses for pictures and gabs a bit with anyone who ventures near.

His admirers come in all ages. There are grandparents who recall the days he socked home runs into the depths of the old Memorial Stadium. There are youngsters who offer up their baseball caps and gloves for Boog's signature. They are vaguely aware of who he is, or was. When, at the urging of their elders, they sidle up to Boog and pose for a cellphone photo with the giant, they look like Lilliputians.

Nine-year-old Owen O'Connor barely came up to Boog's chest when, under the direction of his grandmother Melanie Owen he posed for a picture on Opening Day 2014. "I know he was a really good baseball player," reported the youngster, who added that he had recently watched a vintage televised game of the Orioles' 1970 World Series that featured Boog at first base.

The women look petite when they get near him. Young and old, Boog greets them warmly, flirts with them and puts his massive arms around their shoulders at snapshot time. "He is so genuine, so down here with you, no

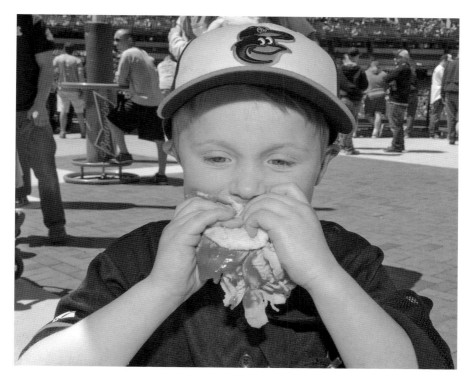

Baseball and barbecue. Young Luke Schwindt devours one of Boog's sandwiches at Camden Yards. *Photo by Jim Burger.*

better than you are," said Sharon Van Culin after emerging from a season-opening Boog bear hug.

The men are constantly telling him about a long-ago game or a time decades ago when they met him at a crab house. At the mention of these moments from the past, Boog pauses and, like a ballplayer scanning the sky for a pop fly, searches his brain for the recollection. More often than not, he snatches it out of the air.

Ken Chodnicki told Boog he had first seen him play in Memorial Stadium in the late 1960s , when Chodnicki was a boy and a member of the Junior Orioles. The ballpark popcorn, Chodnicki recalled, was served in cone-shaped containers that, when emptied, became megaphones through which he and other Junior Orioles used to holler, "Booooog!"

"Boog can make everybody feel as if he remembers them whether he does or not," said Andy Etchebarren, his former Orioles teammate and lifelong friend.

Boog's female fans (from left) Scottie Merritt Marshall, Valarie Goff, Denise Seebode and Pam Wingate stop by his stand for a sandwich and a hug. *Photo by Jim Burger.*

"He has a natural ability to communicate," says Stan "the Fan" Charles, who shared a microphone with Boog on Baltimore sports talk radio shows during the 1990s. "And what he communicates so well is that he is just a guy. Boog never tries to big-time you."

Along with his outsize presence is an equally large personality. Boog is in many ways the unofficial greeter at Oriole Park. In a city that is inordinately proud of its history, Boog links its past, its glory days of world championships against the Sandy Koufax Dodgers and the Pete Rose Reds, to its hopeful present. Baseball treasures tradition, and Boog personifies it. He's a big fella with a big heart who could hit moon shots.

And he sells a good pit beef sandwich.

Boog got his first taste of pit beef in the early 1960s while roaming the outfield of Memorial Stadium. He sniffed it out.

Pit beef, a seasoned cut of top round beef cooked over charcoal, thinly sliced and served on a bun with horseradish sauce, has long been favored

Baltimore fare. It is served at political fundraisers known as bull and oyster roasts. It is a staple of smoky eateries such as Chaps, Pioneer Pit Beef and many others—most located on Route 40, a stretch of four-lane, east–west highway that bisects the city. The Baltimore sandwich has also appeared on Food Network shows such as *Diners, Drive-Ins and Dives* and others that feature local favorites.

Back in the 1960s, Boog was new to Baltimore and pit beef. One day, while shagging flies in the outfield of Memorial Stadium, he smelled something good. A local caterer, Langenfelder's, was cooking beef for a group of Oriole fans in the picnic area behind the center field fence. Boog persuaded one of the cooks to slip him a piece of pit beef through a door in the outfield fence. He was hooked. "It was marvelous stuff," he recalled. He went back for more, even hiding extra pieces in his glove for munching in the dugout.

Decades later, when the Orioles moved to their new downtown ballpark, Oriole Park at Camden Yards, Boog had an idea: set up a pit beef stand in the ballpark. Boog was splitting his time between Baltimore and Key West. First, he rented an apartment in the Anchorage building on Baltimore's Boston Street, and then he bought a home in Cockeysville.

One sunny day in 1991, Boog was played golf with Hugh Gallagher, regional vice-president for Aramark, then the concessionaire for the ballpark. The two were playing in the Save a Heart golf tournament at Turf Valley, and the duo won a top prize. They retreated to the clubhouse to celebrate, a celebration that lasted well into the night. Amid the merriment, Boog pitched the idea of selling pit beef at the ballpark.

Boog had cooked for Gallagher many times. "I sponsored an annual golf tournament at different cities around the country for my clients and friends. Boog would always come out and cook a pig in his 'Cuban microwave,' feeding about 150 people," Gallagher recounted in a 2013 interview. "I knew he knew what he was talking about because I had experienced it."

"I got to watch Boog and see how he reacted to people," Gallagher continued. "He grew up in an era where you earned your money on personal appearances. Just watching him talk to people who remembered him in his glory years…he handled people so well."

Over a bottle or two of Grand Marnier, the victorious duffers kicked around the concept of a pit beef stand at the new stadium. Boog recalls that the session ended "at about three in the morning with Hugh saying he would run the idea up the flagpole."

Gallagher sensed that in addition to Boog's personality and cooking skills, the architecture of the new stadium offered a rare chance to change the way food was

Above and opposite: Exhibition cooking. Letting customers see the pit beef, pork and turkey being smoked, sliced and served are hallmarks of Boog's Camden Yards operation and have been copied at other ballparks. *Photos by Jim Burger*.

presented at ballparks. A plan to knock down the old Camden Yards warehouse had been rejected. That meant, Gallagher reasoned, that the stretch of Eutaw Street running between the ball yard and the warehouse "could become a street fair every night." Presiding over that fair, he thought, could be big Boog Powell.

However, in the good light of day, the initial reaction from Gallagher's colleagues was negative. "I told my guys that my vision was to set something up on Eutaw Street where Boog could be the feature, the draw. They thought I was out of my mind, that it wouldn't work," Gallagher recalled.

Undaunted, the duo persisted. Gallagher lobbied his bosses, while Boog fired up his large Weber grill and cooked top rounds and pork loins, each seasoned with a special mix of McCormick spices, and served sandwiches to skeptical executives. "They went nuts," Boog recalled. Still, the stand was a new concept, a difficult sell.

"We were changing the whole methodology of delivering food in a stadium environment," Gallagher recalled. Instead of the traditional concession stand where the food was prepared out of sight, this would be "exhibition cooking," he said, where customers would see the process and "buy with their eyes."

Workers at Boog's Camden Yards operation all wear Boog's number twenty-six Orioles jersey. *Photo by Jim Burger.*

Gallagher and Boog kept pushing, and as a compromise, they got a stand set up in the left-field picnic area for the first exhibition game in Camden Yards. "We ended up putting Boog in the picnic bullpen area, and even there, people were lined up to buy his sandwiches," Gallagher said. "We ran out of food by the about the second inning," Boog recalled. "People were coming at us from all directions."

The size of the sandwich-eating crowd convinced Aramark executives that the concept was a good one. The market had spoken. A move needed to be made from the bullpen. Boog's stand was set up on the Eutaw Street promenade.

"Everyone was skeptical at first, but once we had that experience in the bullpen, they were much more receptive. We came up with a way to mass-produce his product under his supervision and guidance, and it just turned out to be a home run," Gallagher said. Aramark number crunchers saw per-capita sales triple at Camden Yards over sales at Memorial Stadium. Something was happening here, and not just on Eutaw Street. The denizens of the club level, where the air is rare and the seats are in suites, wanted access to Boog's smoky delights as well. "The people on the club level insisted that they have some Boog food up there," Gallagher said. And so a barbecue

"satellite" stand, perhaps the first so-named in the history of barbecue, was set up in the club level.

On Eutaw Street, sales were so strong that, as Boog put it, "we couldn't take the money fast enough." The backup at cashiers was so long that extra cash registers were added. "Aramark thought we would do a couple of hundred thousand dollars for the year," Boog recalled. "We did that in the first months."

Word of the success of Camden Yards, its architecture and the stadium fare spread like a hot potato through the ranks of major-league owners. "We had everybody come through the stadium in the first couple of years," Gallagher said. "All the other teams and people who were planning new stadiums…they loved what the saw, and they took bits and pieces of it back to their operations."

And so the "Boog concept" of a former player serving as host to a stadium food operation spread around the country. In Philadelphia, it was Greg Luzinski; in Pittsburgh, Manny Sanguillen; in San Francisco, Orlando Cepeda; and in San Diego, Randy Jones.

Boog's stand won high praise from Josh Pahigian and Kevin O'Connell, who toured all thirty major-league baseball stadiums in 2003 and wrote *The Ultimate Baseball Road Trip: A Fan's Guide to Major League Stadiums*. "Just as Camden began the retro trend in ballpark design," they wrote, "Boog began the barbecue trend in ballpark cuisine."

Boog and Gallagher penned the details of their Camden Yards agreement on a napkin at Hooters in the Inner Harbor. "We had a bucket of chicken wings and a bottle of Dom Perignon," Gallagher said. "I went back to my folks at Aramark, and they agreed to pay half his salary. The people at Miller brewery worked a deal with the distributorship for the remainder, and the rest is history."

In 2004, Boog sold the Cockeysville home and moved to Grasonville on Maryland's Eastern Shore. More than eighty times a year, every time the Orioles are playing in Baltimore, Boog gets in his pickup truck and drives from his home just over the Bay Bridge to the ballpark. "I leave about five o'clock, and it takes about an hour," he reports. "But every once in a while, I get stopped at the bridge. There will be an accident, and I will call Annie [assistant manager Ann O'Brien] and tell her, 'I can't make it today—the bridge got me.'"

On Eutaw Street, he greets, signs and smiles virtually nonstop until the second inning. Then he jumps in his truck and heads back home to relieve an aide who is caring for his ailing wife. Most nights, he is home by 8:30 p.m.

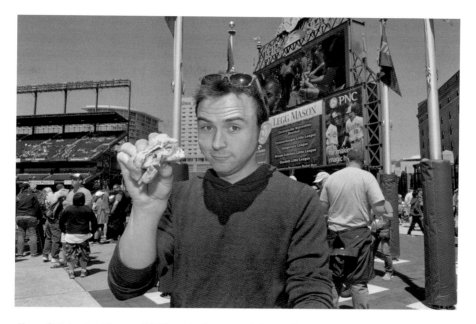

Above: Orioles fan Tommy McFly enjoying a good day and a good sandwich at one of baseball's best ballparks. *Photo by Jim Burger.*

Opposite, top: Legends of Baltimore meet. Former Baltimore mayor and Maryland governor William Donald Schaefer wished Boog well at the opening of his Camden Yards stand in 1992. *Author's collection.*

Opposite, bottom: Boog and Anne O'Brien, manager of the Camden Yards stand, who, according to Boog, makes everything run. *Photo by Jim Burger.*

"Jan was the brains of the operation," recalls Merv Rettenmund, who along with his wife, Susan, socialized with the Powells when the men played baseball in Memorial Stadium and the families lived a few blocks away on Medford Road. "Jan was very business smart."

Some nights, a former teammate will drop by Boog's Camden Yards stand to say hello. One night in 1997, it was Jackie Brandt, who played with Boog from 1960 to 1965. Another night in 2013, it was Al Bumbry, whose first years with the Orioles, 1972–74, were Boog's last. The camaraderie that comes from playing on a major-league team is hard to forget, Boog says. "When you play 162 games in 175 days, you get pretty close to these guys. You know a lot of about them; they know a lot about you. It is a unique fraternity because we play so many games together. In football, you have one game a week; in baseball, you have maybe six games a week. I had some

123

really good roommates—Jerry Adair, Johnny Temple, Pat Dobson, Eddie Fisher. They are all gone except for Eddie."

There are some game nights when Boog doesn't feel like being sociable. A few visitors who come by the stand are nasty—mostly Mets fans who remind him about the '69 World Series, still a sore spot after forty-five years. But Boog answers the bell. He likens his current occupation to the time he spent in uniform on the diamond. There were days when he wasn't at his best, but he suited up, showed up and took his swings.

"If I had to do what Booger does—deal with those lines of people every night—I would burn out," Rettenmund observed.

"I look forward to it," Boog says of his Camden Yards duty. "That is what I do—letting folks know I am one of you."

Gallagher, now general manager of the Los Angeles Coliseum and Hollywood Park Casino, looks back and ticks off the factors that first made the lines form at Boog's Baltimore stand and have kept customers coming. Good design and close control of the product have been important, he said, as has the continued presence of the former first-sacker and relationship he has with the fans of the Orioles.

The job, Gallagher said, is not for everybody: "You have got to have a personality that meshes with the character of the city." Greg Luzinski, a blue-collar guy, works in Philadelphia, he said, but Mike Schmidt, the aloof former Philadelphia third basemen, would not. As for Baltimore, Gallagher said, "If we had put someone in there who didn't have that ability to communicate with people that Boog has, well, I can see why people might say the idea was crazy."

Boog has a slightly different take on the stand's success, one connected to the quality of the food. Boog does not cook the meat; that task falls to the stadium concessionaire, now Delaware North. But he supervises the operation and can be a stickler for details. For instance, he likes to see the pit beef come out of the ballpark kitchens at 110 degrees, and he likes to see it come off the slicer at the stand looking a bit rare, "with a little red on it." These, he said, are the keys to a juicy sandwich. Barbecued pork and turkey sandwiches are also on the menu.

He likes to tell the story about a time Davey Johnson, his former Orioles teammate (and later manager of several major-league teams, including the Orioles, Mets and Washington Nationals), dropped by Camden Yards. "Davey came by the stand one day. He said that the sandwich was pretty good. But he said people would come to see me even if it wasn't," Boog recalled. "I told him, 'Davey, if I serve a horseshit sandwich, they will only come once.'"

CHAPTER 12
BOOG'S KITCHEN

Boog likes to cook—always has, always will. "There is a sense of satisfaction that comes from putting a good meal on the table," he explains. Moreover, he says the relaxed atmosphere of dining in your home is hard to beat. Finally, there is flavor—the hard-to-match delight that results from fresh ingredients (some you have grown, some you have caught) prepared just the way you like them.

Boog has other hobbies. He is a golfer. "He hits the ball a country mile," reports Jack Hughes, a former Baltimore-area advertising executive who regularly plays golf with Boog. "But if he hits the ball in the lake, he laughs," Hughes said. "He is not one of those guys who throws his clubs."

He used to play tennis, teaming up with former *Evening Sun* sportswriter Phil Jackman in games of doubles against his Oriole teammates at courts on Perring Parkway. "Boog, like all ballplayers, never mishit a ball," Jackman recalled. "He was very good at putting the ball in the middle of the racket. He didn't move much but had good hands."

He fishes and crabs, hauling in giant grouper in the Gulf of Mexico in the winter and trout-lining for Chesapeake Bay blue crabs in the summer. "Nobody can clean a fish like Boog," says Rod Rodriguez, a longtime fishing buddy in Key West. "His hands are so big and he is so strong that he goes right though those fish in no time."

Boog gardens, nourishing pots of fiery peppers, some so hot they make grown men holler, "No mas!" He has a long-standing relationship with tomatoes. He once grew them competitively, matching his Big Boys and Better Boys with those

Above: Headed for Boog's table, a once-angry blue crab is calmed down in icy water. *Photo by Jim Burger.*

Opposite: Boog's crab pot, filled with the day's catch, is ready for the fire. Later, Boog and J.W. admire the day's lunch, a tray of steamed blue crabs. *Photos by Jim Burger.*

grown by Orioles manager Earl Weaver and groundskeeper Pat Santarone. Then it was all about bragging rights. Nowadays he grows heirloom tomatoes for his personal pleasure and cherry tomatoes for his martinis.

On many days, the kitchen is where Boog spends his idle hours. Whether he is making conch chowder, a dish that requires an afternoon, or steaming crabs with his son, J.W., in a cooker fashioned from an old beer keg, he is at home among the pots and pans. Then there is the barbecue grill, whose fires he tends almost nightly.

"I bet there are not a thousand people in the world who know as much about barbecue as Boog," says Randy McNees. McNees has a unique arrangement with Boog. He teaches Boog about the fine points of computers. Boog, in turn, teaches him about the fine points of barbecuing. One barbecue insight McNees has picked up from Boog is that smoke is an ingredient that should

be employed sparingly. The smoke of fruit woods like apple add elegant flavor to pork and fish, and the smoke of woods like mesquite and cherry deepens the taste of red meats, but only if it is applied in moderation.

Boog's cooking is a mixture of styles, says Wayne Dougherty, a friend of the Powell family for twenty-five years and a regular at their dinner table. "He cooks like he is in the Caribbean, like he is a Cajun and like he is living in Georgia," says Dougherty, who adds that "it is hard to get up from Boog's table."

Boog's culinary education began when he was a boy growing up in Florida. His mother, Julia Mae, was a good cook but died when Boog was ten, at which point his grandmother Rucy took over kitchen duties. From his grandmother, he learned how to make a meal with few ingredients and how to make biscuits. Her clabber biscuits, made from soured milk, were heavenly. Boog's shortcut biscuits are easy to make, but he concedes that they can't touch those made by his grandmother.

His father, Red, introduced him to cooking over an open fire. One day when Boog and his brothers were "camping" in the phosphate pits behind their house, their dad came out and showed them how to cook ribs over a fire of green hickory wood. It is still the best way to cook ribs, Boog believes—just salt, pepper and hickory smoke. Before there were fancy barbecue grills adorning every backyard, his dad cooked steaks using grates from an old refrigerator and roasted oysters using a piece of wire fencing to hold the mollusks over the flames. Ben Howell, a friend of the family, taught Boog and his brothers how to cook game and how to tell stories around a campfire: mix equal parts drama, exaggeration and humor.

Although the loss of his mother introduced sorrow to his boyhood, family meals were nonetheless times of conviviality. Joke-telling was part of the evening menu, and as a mischievous youth, he discovered that you could have fun with fish parts. Back in the day when cars had hubcaps, Boog would pop the hubcap off a wheel of the car of a target—usually a buddy—and put a fish head or sometimes a whole fish inside the hubcap and put it back on the car. In a short time, the smell would be awful, and the clueless car owner would be ripping the vehicle apart looking for the offending carcass. Boog admits to "hubcapping" several friends.

As a professional baseball player, Boog saw the world and expanded his culinary horizons. He tasted Kobe beef in Japan, dined in fine restaurants throughout the United States and encountered local specialties such as menudo, a Mexican dish made with cow's stomach and hominy that cures hangovers. It worked for Boog one time in Los Angeles. Before the

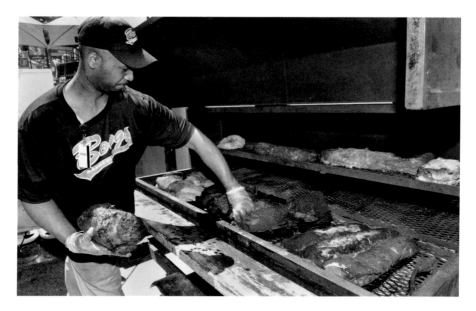

Keeping the pit beef juicy, one of Boog's Camden Yards crew keeps an eye on the meat, making sure it is not overcooked. *Photo by Jim Burger.*

menudo, he felt lousy; after the menudo, he hit a home run off Angels ace Andy Messersmith.

After his playing career ended, Boog's interest in cooking intensified. The marina he ran for thirteen years in Key West became known for the fish fries and barbecue feasts it put on for boaters. "Anytime there was an opportunity, Boog cooked," recalls Jim Halloran, who sold Boog the Key West marina. Boog got a great deal on a railroad car full of mesquite, and soon he and his buddy Rod Rodriguez were cooking everything in sight with the smoky wood. In 1986, he collaborated with editors on *Mesquite Cookery*, a cookbook. In 2001, he opened a restaurant, Boog's Bar-B-Q, with his son, J.W., in Ocean City, Maryland. And since 1992, he has presided over a barbecue stand at Oriole Park at Camden Yards.

Boog's daughters and son cook as well. "We are not bakers," elder daughter Jennifer Powell Smith says. Rather than using precise measurements, the Powells "look at a couple of different recipes, pull some from here, some from there" and then figure out what to do.

Using this style of cooking, their dad, younger daughter Jill Powell remembers, has pulled off some pretty impressive feats. One Mother's Day, Boog and a fellow dad tossed a grill in a boat, motored out to an uninhabited island in the

Florida Keys and served a Mother's Day brunch complete with eggs Benedict and mimosas to their wives. On the island, Jill helped her dad poach eggs in beer cans. They cut off the top of four Miller Lite cans, put in a mixture of wine and salt water and simmered the "beer-can poached eggs" on the grill.

Following are some of Boog's favorite dishes:

BOOG'S PIT BEEF
Serves 8

3 pounds boneless eye of round
2½ teaspoons kosher or other
 large-grain salt
1 teaspoon freshly ground
 black pepper
2 teaspoons paprika

½ teaspoon garlic powder
½ teaspoon dried oregano
¼ teaspoon cayenne pepper
2 teaspoons vegetable oil
8 Kaiser rolls
1 yellow onion thinly sliced

SAUCE

¹/₃ cup prepared horseradish, drained
¹/₃ cup mayonnaise
1 teaspoon fresh lemon juice
1 garlic clove, minced
A pinch of cayenne
Salt and pepper to taste

FOR THE SAUCE: *Mix all ingredients in a bowl and season with salt and pepper.*

FOR THE BEEF: *Combine salt, pepper, paprika, garlic powder, oregano and cayenne pepper in a bowl. Pat the meat dry and then rub with mixture. Wrap beef in plastic wrap and let sit at room temperature for at least an hour, or refrigerate for twenty-four hours, but allow meat to sit at room temperature for an hour before grilling. Unwrap meat and rub with oil. For charcoal grill, open bottom vents completely. Fill a large chimney starter with briquettes (lump charcoal is best, as it burns hotter, but normal briquettes will do). When coals are glowing, pour them over half of the grill in an even layer. Put grill in place, open top vents, place cover on grill and let it heat for 5 minutes. Place meat directly over coals. Turn frequently until all sides are equally blackened and then put meat on the cooler side of grill away from fire. Cook for about 30 minutes until the center of the meat registers 95 to*

100 degrees on an instant-read thermometer. Transfer meat to carving board, tent with foil and let rest. Meat will continue to cook and after resting for 30 minutes should register 120 to 125 (medium rare) degrees on instant-read thermometer. Cut the roast in half lengthwise and then slice it against the grain in very thin slices. Heat rolls briefly on the grill, being careful not to burn them. Serve meat on rolls and top with sauce and slice of onion.

BOOG`S PORK RIB RUB

Yield: ¾ cup

2 tablespoons black pepper
3 tablespoons kosher salt
1½ tablespoons garlic powder
1 tablespoon cayenne pepper
3 tablespoons chili powder
3 tablespoons paprika
1 tablespoon cumin

Mix all ingredients in a large bowl and store in airtight container.

BOOG`S PORK RIBS

Serves 6

2 racks pork ribs about 4 pounds each
4 handfuls of hickory wood chips soaked in water

Skin the ribs by removing the membrane on the underside of the ribs. This allows the rub seasoning to penetrate the meat. Good tools for this are an oyster knife to pry the membrane from a bone at the end of the rack and a paper towel to grip the freed piece of membrane and peel off the rest. Coat both sides of the ribs with the rub. Save remainder of rub, storing in airtight container. Prepare a fire in your grill for indirect cooking. On lower grate opposite the coals, place a foil pan to catch drippings. Toss half of wood chips onto coals.

Place ribs on cooler side of the upper grill grate, placing them on grill rack if you have one. If not, place ribs bone side down on grill. If cooking with charcoal, open vents on bottom and top of cooker about halfway. A low, steady fire is best. Cover the grill and cook for about two hours. Ribs should be tender but not mushy. Remove from grill and let rest. To keep ribs warm while preparing other dishes, loosely cover (but do not wrap) in foil. Serve with your favorite table sauce or as is.

BOOG`S BEEF RIBS

Serves 4

8 beef ribs, English-style cut (different from short ribs)
Water
1 tablespoon meat tenderizer
1 cup tarragon vinegar (see note)
4 cups breadcrumbs
Salt and pepper to taste

Using a sharp knife, remove the blue skin from each rib. Place ribs on a metal sheet pan or in a large glass baking dish. Sprinkle each rib with water and then sprinkle with meat tenderizer. Using a sharp fork, poke holes in the ribs. Pour vinegar over ribs and let marinate for no more than two hours, flipping them halfway through the process. Remove ribs from marinade, pat them dry and then toss them with breadcrumbs. Prepare grill fire. If using charcoal, place hot coals under one side of grill grate, leaving other side empty. If using gas grill, turn on one side of grill and leave other side off. Toss ribs a second time in breadcrumbs. Place ribs directly over the fire, bone side down. To prevent ribs and breadcrumbs from blackening, use tongs to occasionally move ribs from hot side of grill to cool side and then back again. Cook until medium rare, registering 130–135 degrees on an instant-read thermometer, for about 30 to 40 minutes. Remove from fire, let rest for 4 minutes and add salt and pepper to taste. Serve with boiled egg noodles tossed with poppy seeds, sliced green olives and butter and add a salad tossed with a tarragon vinaigrette.

NOTE: *Tarragon vinegar can be made at home by letting two cups of bruised tarragon leaves sit in two cups of white vinegar in a closed container for two weeks. If in a hurry, place 1 tablespoon dried tarragon leaves in 1 cup white or cider vinegar, let sit for an hour or two and then strain.*

BOOG`S GROUPER

Serves 4–6

6 grouper fillets, 6 ounces each
6 eggs, beaten
1 cup milk
1 tablespoon garlic salt

2 teaspoons fresh black pepper
2 tablespoons Tabasco sauce
12 Zesta saltines, finely crushed
2 cups cooking oil

In large skillet, heat oil until it reaches 360 degrees or until a piece of bread dropped in heated oil turns brown and floats. In a large bowl, mix eggs, milk, garlic salt, pepper and Tabasco sauce. Dip fillets in liquid and then roll in crushed saltines. Carefully place in hot oil and fry until golden brown, about 3 minutes per side. Serve with sesame coleslaw.

CHARLIE LAU`S MACKEREL

Serves 4

2 pounds mackerel
1 cup flour
1 teaspoon salt
1 cup water
1 tablespoon vegetable oil
1 egg, beaten
1 cup vegetable oil for frying

Gut, behead and skin mackerel. The skin is slippery, so cut fish into quarters 4–6 inches long, insert knife under skin and loosen skin. Remove dark flesh. Mix flour and salt. Separately in a large bowl, whisk the tablespoon of oil and water and then slowly add flour and salt mixture. Add the egg. Mix well. Heat the oil in a large skillet over medium-high heat until oil shimmers. Drop fish in batter and fry until crisp and brown, about 2 to 3 minutes per side. Remove fish, dry with paper towels and cover. Repeat until all fish is fried, making sure oil is hot each time a fresh batch of fish is ready.

OPTIONAL: *When all fish have been fried, briefly dip it again in hot oil for added crispness.*

KATHI KRAMER`S BROILED OYSTERS WITH CREAMED SPINACH

Serves 4

12 dozen oysters opened but left in lower shell
Rock salt
12 ounces Pernod
12 ounces creamed spinach (see below)
6 slices of bacon, cut in two
4 ounces fontina cheese

Place rack in middle of oven and preheat oven to "broil." Cover a large baking sheet with rock salt. Place oysters evenly on salt-covered baking sheet. Sprinkle each oyster with 1 teaspoon Pernod. Put a dollop of spinach covered with a slice of cheese on each oyster. Top each with a slice of bacon. Place under broiler and cook until bacon crisps, about 4 minutes.

CREAMED SPINACH

3 pounds fresh spinach
4 tablespoons butter
¼ cup flour
1 tablespoon grated onion

2 cups chicken stock
1 teaspoon salt
¼ teaspoon freshly ground black pepper

Wash the spinach thoroughly in cold water. Place wet spinach in a large, lidded pot; cover; and cook until spinach wilts. Drain and finely chop the spinach. Heat butter in a large skillet, add the flour and onion and cook, stirring until the mixture browns. Add the stock gradually, constantly stirring until the mixture has thickened and is smooth. Add the spinach, salt and pepper and simmer for several minutes.

HOT PEPPER PASTE FOR GRILLED FISH

2 hot peppers (jalapeno, serrano or Thai), seeded and chopped
2 garlic cloves, chopped
1 small onion, chopped

1 tablespoon fresh ginger, grated
1 teaspoon ground turmeric
10 saffron threads soaked in water
2 tablespoons fresh lemon juice
¼ cup unsweetened coconut milk
2 teaspoons fresh cilantro, chopped
Salt to taste

Combine all ingredients except the salt in a blender and puree the mixture for about 2 minutes. It should be a paste. Spread the mixture over any full-flavored fish fillets (salmon, tuna, mackerel, swordfish). Let covered fish marinate in the refrigerator for at least 30 minutes. Refrigerate any leftover paste (it can be used on chicken as well). Prepare a fire in the grill. Gently transfer the fish to the grill and cook over direct heat until fish can be easily pierced with a probe, unless it is tuna, which should be rare in center.

JAN`S TOMATO JUICE

Yield: 2½ cups

3 ripe tomatoes, about 1½ pounds, quartered
1 rib of celery with leaves cut into 3-inch pieces
1 carrot, peeled and cut into small pieces
3 basil leaves
1 clove garlic
1 onion quartered
1 teaspoon Worcestershire sauce
¼ teaspoon sea salt
⅛ teaspoon fresh ground pepper

In a food processor, combine tomato, celery, carrot, basil, garlic, onion and Worcestershire sauce and puree until smooth. Pour the mixture into a large, microwave-safe bowl. Cook on full power for 6 minutes. (Note: If microwave is less powerful than 650 watts, cook approximately three more minutes.) Pass mixture through a food mill. Season with salt and pepper. Return the mixture to the ovenproof bowl and cook uncovered in microwave another 3 minutes. Chill and serve.

BOOG`S GREENS AND PORK

Serves 6

2–3 pounds greens (collard, mustard and/or turnip greens),
 stemmed and washed (see note)
2–3 ham hocks or smoked ham shanks
2–3 pounds country-style ribs
I onion, thinly sliced
3–4 turnips (optional), washed, peeled and quartered
Salt to taste

In a large pot, cover the ham with water, add onion, put on lid and cook at low boil until meat is tender, about 1 hour. Using a slotted spoon, remove the ham and place on cutting board. Trim fat from ham. Return ham meat to pot of flavored water, turn heat to medium, add greens and let them begin to cook down on slow boil. Sprinkle country ribs with garlic salt and black pepper and then add ribs to greens, pushing them down into pot. Cover and cook at medium heat for about 30 minutes. If using turnips, add them for the last 30 minutes of cooking time, as they will fall apart if added sooner.

NOTE: Greens can be very sandy. One way to clean big bunches of them is to toss them in the dishwasher and run the rinse cycle with the hot water turned off.

BOOG`S CUCUMBER SALAD

Serves 4

2 cucumbers, peeled and sliced
I teaspoon salt
I teaspoon white vinegar
I sweet onion, minced
½ cup mayonnaise
¼ cup sour cream
I tablespoon fresh chopped dill
Fresh ground pepper to taste

Place sliced cucumbers in a glass bowl and toss with salt and vinegar. Let sit for 30 minutes. Place in colander and let drain for another 30 minutes. Add the onion, mayonnaise, sour cream, dill and pepper and mix well. Cover and refrigerate for at least 30 minutes before serving.

CONCH SALAD

Serves 4

1 pound clean conch, diced
¼ cup orange juice
2 tablespoons lime juice
2 tablespoons lemon juice
1 hot pepper (jalapeno or similar), seeded, stemmed and minced
2 tablespoons extra virgin olive oil
1 tablespoon coarse salt (sea or kosher)
1 tablespoon cilantro, chopped
1 cucumber, peeled, minced
½ yellow bell pepper, minced
½ red bell pepper, minced
¼ red onion, minced
½ cup fresh tomato, diced
¼ cup avocado, diced

Combine all of the ingredients except tomato and avocado in a large bowl. Stir and refrigerate for at least 2 hours. When serving, fold in the tomato and avocado. Serve in chilled bowls.

CONCH CHOWDER

Serves 6–8

1 pound conch, trimmed
3–4 tablespoons fresh lime juice
5 tablespoons tomato paste
2–3 pieces of salt pork cut into ¼-inch pieces
3 tablespoons extra virgin olive oil
1 onion finely chopped
1 carrot finely chopped
2 ribs celery finely chopped
3 garlic cloves, finely chopped
1 green pepper, cored seeded finely chopped

3 ripe tomatoes, peeled, seeded and finely chopped
¼ cup dark or golden rum
¼ cup dry sherry
1½ pounds potatoes, peeled and diced
2 bay leaves
1 teaspoon dried thyme
½ cup Italian parsley, chopped
8 cups water
1 tablespoon Worcestershire sauce
1 teaspoon Tabasco
Salt and freshly ground black pepper to taste

Pound the conch with a meat mallet for one minute and then cut into 1-inch pieces or grind in a meat grinder or food processor. Combine the conch, 2 tablespoons of the lime juice and tomato paste in a bowl and mix well. Set aside. In a large, heavy pot, brown the salt pork in 1 teaspoon of olive oil. Add the remaining olive oil, as well as the onion, carrot, celery, garlic and bell pepper. Cook over medium heat until vegetables are slightly browned, about 5 to 6 minutes. Stir in the tomatoes, increase the heat to high and cook for 1 minute. Add the rum and sherry and bring to a boil. Stir in the conch mixture, bay leaves, thyme, ¼ cup of parsley, water, Worcestershire sauce, Tabasco and salt and pepper. Bring the mixture to a boil. Reduce the heat and simmer the chowder uncovered until the conch is tender, about 1 hour. Add the potatoes and let cook another 15 to 20 minutes. Before serving, remove the bay leaves and correct the seasonings, adding salt, pepper and 1 to 2 tablespoons of lime juice, Worcestershire or Tabasco sauce or sherry to taste. Sprinkle with remaining parsley and serve at once.

BOOG'S SHORTCUT BISCUITS

Yield: 24 biscuits

3¼ cups Southern Biscuit Mix Formula L
1¼ cups buttermilk for finished biscuits (add ¼ cup more if making
 drop biscuits)

Preheat oven to 450 degrees. Mix buttermilk into biscuit mix with a wooden spoon, using as few strokes as possible. If making "drop biscuits," spoon servings of dough onto buttered

baking sheet. If making finished biscuits, turn dough on lightly floured surface and then roll dough until it reaches a thickness of a ½ inch. Using a biscuit cutter, cut biscuits from dough and place onto buttered baking sheet. Bake until lightly browned, 10 to 12 minutes. Remove from oven, brush tops with melted butter and serve warm.

BOOG`S GRILLED ASPARAGUS

Serves 4

1 bunch asparagus (¾ pound), woody ends trimmed
3 tablespoons olive oil (divided use)
8 thick, long-stemmed rosemary sprigs
2 strips of lemon zest, julienned
2 garlic cloves, slivered
¼ cup snipped chives
½ teaspoon salt
¼ teaspoon freshly ground black pepper
¼ cup Parmesan cheese, grated

Heat grill to medium. Toss the asparagus with 1 tablespoon of the olive oil. Place a sheet of aluminum foil on the grill grate or use a grill basket. Arrange the rosemary on the foil and then place the asparagus over and perpendicular to the rosemary sprigs. Grill until the asparagus softens and becomes lightly browned all over, turning every minute or so to ensure even cooking. It will take 10 to 15 minutes, depending on the thickness of the asparagus. The asparagus will be crisp-tender. Remove the asparagus to a platter. Discard the rosemary sprigs. In a bowl, mix the lemon zest, garlic, chives, salt, pepper and the remaining olive oil. Toss asparagus to coat well and then sprinkle with cheese. Serve hot, warm or at room temperature.

CHAPTER 13
TEAMMATES HAVE THEIR SAY

Boog developed friendships with many colleagues during his seventeen years in the major leagues. Here is the appraisal from some of his fellow ballplayers about Boog's baseball abilities, his cooking and his personality.

Merv Rettenmund, Brooks Robinson, Boog and Frank Robinson at the 1970 World Series. *Author's collection.*

BROOKS ROBINSON—FORMER ORIOLES THIRD BASEMAN AND BOOG'S TEAMMATE, 1961–74

On Boog's fielding: He was a wonderful target to throw to; he was big and limber, and he moved around. He had good hands and fielded the ball well. I had to throw to Jim Gentile, who was a great guy to throw to, and Bobby Boyd, who was short and had average hands. You almost had to make a perfect throw. But in Boog's case, I could throw it anywhere I wanted to.

I remember the first ball that was hit to me in the '70 World Series. It was like a little twenty-four-hopper. I think Woody Woodward [Cincinnati Reds infielder] hit it, and I made a high throw to Boog for an error. And you know, if you make a high throw to Boog, it has to be really high. Everything else in that series turned out pretty good for me. [Brooks was named World Series MVP.]

Boog kept track of all the bad throws I made to him. At the end of the year, he said, "Hey Brooks, you made about fifteen errors and I saved you about ten, so you owe me a Gold Glove."

On Boog's hitting: He was very accomplished. I always considered Memorial Stadium to be a real pitchers' park. I mean it was short down the line but veered out to 380 feet and 410 feet. You really had to hit one to get it out of there. If Boog had played anywhere else, he would have a lot more home runs. He just was that good a hitter.

The Orioles were always talking to him about his weight. I don't know what Boog weighed, but if he weighed 250 and had a bad year, they would say, "You gotta lose weight." And the next year, if he weighed 250 and had a good year, they would say, "We like you just the way you are."

He didn't get the press he should. If he had played in this ballpark here [Camden Yards]…oh my goodness, that would be another story.

He used to say he never hit one good. He would hit one 450 feet and come back in the dugout and say, "Damn, I just missed that ball."

On Boog's personality: He is as down to earth as he could be. He enjoyed life, and when he was on the field, he enjoyed that, too. He never complained and went out there every day and played hard. He lived large, but he was always ready to play every game.

Boog bought a house on Medford Road two houses down from me. McNally lived around there, and so did Davey Johnson. Sometimes we

would walk to the stadium, but mostly we would drive. It was a short drive. Our wives, Jan and Connie, got together, and the kids played together.

Boog could not have been a better friend. He would do anything for you. When he won the MVP in 1970, we were so proud. Now we get together once a month or so in the summer to have crabs together. He never lets me forget that his season high for stolen bases, seven, is higher than mine.

MERV RETTENMUND—FORMER ORIOLES OUTFIELDER AND BOOG'S TEAMMATE, 1968–73

On Boog's hitting: Boog was underrated as a hitter. I don't consider him just a home run hitter. He had the ability to hit for average. Boy, he had a good swing out to left and left center, and when you see guys who can do that…wow! It is a long swing. He goes forward. He drops his hands, but he gets his hands back up. I had that hitch, too.

I coached hitting in the big leagues for eighteen years. Now if I tried to get hitters to swing like Boog Powell, to drop their hands and get them back up, there would be some criticism.

Boog was smart enough to look for pitches. If he got them, he hit them. And if he didn't hit them and got called out on strike three, he would just come back and say it was not his day. He was on such an even keel. You never knew if Boog was two for twenty or ten for twenty.

On Boog's fielding: He was really agile and good around the bag. He had a good set of hands.

On the road: Boog would always go to the best restaurants, like Durgin Park in Boston. It was always good to go with Boog because you would go right to the front of the line. Either that or you would go in the back door, up the stairs. He knew all the shortcuts. It was like that in Baltimore, too, at all the crab houses.

In Japan after the 1971 World Series, the food was amazing. There were baskets of food on the bus. In the locker room, food was served on china. As we were leaving Japan, I asked Boog, "How much are you weighing now?" and he said, "Somewhere between three and four."

He roomed one year with Pat Dobson, a pitcher, and it is tough to room with a pitcher; because of their schedules [pitching only every fourth day],

they can go out and stay out all night. I think Boog spent that whole year without sleep.

In the locker room: After the game, we would sit in the locker room and talk. We'd be in there for an hour talking. Sometimes it was bad, sometimes it was good. That is baseball. Then Boog would be talking with [Earl] Weaver and [Ralph] Salvon about fertilizer and about who had the biggest tomatoes. Weaver always wanted to win.

In Boog's backyard: We lived near each other in Towson near Calvert Hall in row homes. His backyard, even in a row home, was filled with tomatoes and peppers. After a ballgame, we would go out eating crabs or we would go over to Boog's house. We would never eat until at least two o'clock in the morning. He had a Weber grill that was about four feet across.

I would pick up Booger some mornings, and he didn't look too good. And I would say, "Catfish Hunter is pitching against us today." And Boog would say, "I hope he has the best stuff he ever had in his life." And Boog would go out there and let it go, and it worked. It worked real good.

At the Camden Yards stand: Boog puts on a program. That is his job, and that is why he is so successful. You put a name player behind something like that, and in other places you will see him once a home stand. Boog is there almost every night. If I had to do it like Boog does, greeting those lines of people, I would burn out.

On Boog's reputation beyond Baltimore: When he was with the Dodgers, we went down to an event at the Miramar Air Force Base in San Diego one day, and it was just amazing how people would take to him. He had never played here, and San Diego is not the sports mecca of the United States. Maybe it was his size or his smile or the Miller Lite ads, but people knew him.

In Cleveland, they spoke extremely highly of him. I think it was Freddy Kendall [Indians catcher] who said that if you couldn't get along with Boog, you had a problem.

EDDIE FISHER—FORMER PITCHER AND BOOG'S ORIOLES TEAMMATE AND ROOMMATE, 1966–67

On how he pitched to Boog when they were on opposing teams: I fed him knuckleballs. I either got him out or I didn't. He didn't hit the knuckleball bad.

On Boog as a roommate: Boog has a lot of personality. He was kind of a leader in the clubhouse, an agitator when things were going good.

Boog and I were both country music fans, and every time we were on the road, we always managed to find a country music spot. We would catch Roy Clark every time and became good friends with him.

We fished together quite a bit. And in spring training one night in Florida, we took two boatloads of players out to a lighthouse where Boog knew the fellow who ran it. Boog and Charlie [Lau] were good divers, and they would throw these lobsters up to us. We boiled them and had a heck of a feast.

On Boog as a visitor: Boog and Brooks came down to Oklahoma to help us open up our sporting goods store. After the opening, Brooks went back to Baltimore, but we couldn't get rid of Boog. He stayed for days. We had a big

Happy Birds. Boog douses Mark Belanger with champagne as Brooks Robinson (far right) and Billy Hunter and Dave McNally (left) celebrate winning the Eastern Division in 1974. *Reprinted with permission of the Baltimore Sun Media Group. All rights reserved.*

fish fry, and one of my buddies made this Mexican corn bread with creamed corn and jalapenos that Boog loved.

On Boog as a cook: He is darn good at it. I remember when he was just getting started at the ballpark. He had five big Weber kettles, and he put on twenty-pound roasts and cooked them all night and took them down to the ballpark. He cans his own tomatoes—then there is his hot sauce. He likes it super hot with habanero peppers in it.

On Boog as a fixture in Baltimore: I went to a Ravens game with him. As we walked to the game, people would see him and start hollering, "Boog! Boog!" He would smile, wave and talk to people. He is so good about doing that. I think he is the most popular ex-ballplayer who lives in Baltimore.

ANDY ETCHEBARREN—FORMER CATCHER AND BOOG'S ORIOLES TEAMMATE, 1962–74

On avoiding collisions with Boog: On a pop-up, you always wondered if Boog was going to run over you. But he never did. On a pop-up, if I didn't hear anything from Brooks or Boog, they were mine. Brooks and Boog were very good; they got most of them.

On how Boog introduced him to oysters: In spring training in Miami in 1962, we were all married and rented these apartments off Biscayne Boulevard. After a workout, Boog went out and got a bunch of oysters and brought them over to the apartment. He said, "You gotta eat some of these." I was a California boy, and I said, "I am not eating those things." He said, "If you don't eat some oysters, I am gonna throw you off the apartment balcony." I ate them. I didn't like them much that day, but I like them now.

On Boog as a Baltimore host: After the games, our wives would get mad at us because they would be outside the clubhouse waiting, and we would be in the clubhouse drinking beer.

We did not make much money. So we would have parties at his house, and he would barbecue for everybody. I think he also introduced us to Manhattans and to vodka Gibsons with onions in them.

On why he has more triples (seventeen) than Boog (eleven): He couldn't run with me. If we would have a foot race, I would beat him every time. He did steal more bases than I did [Boog had twenty, while Andy had thirteen]. He was so big that nobody paid any attention to him, and he would just take off.

JIM PALMER—FORMER PITCHER AND BOOG'S ORIOLES TEAMMATE, 1965–74

On Boog's fielding: Two of my favorite Boog stories are from the Houston Astrodome. We were playing an exhibition game there in 1965, before the season opened. This was when they had glass in the ceiling of the Astrodome so that sunlight could come in for the grass. But when a fly ball traveled under that glass, outfielders couldn't see it. Boog was playing left field, and so to protect himself, he wore a batting helmet in the outfield. One fly ball landed about fifteen feet from him. He never saw it, but thanks to the helmet, he didn't get hit in the head. Later the glass was painted.

Then, in 1970, we were back in the Astrodome, again before the season started. By then, they had replaced the grass with Astroturf. The Astros had John Mayberry and a bunch of left-handed hitters, and I was experimenting, trying to see what my slider would do to lefties. They were hitting some rockets on Astroturf, right at Boog down at first base. After about three or four innings of knocking down these shots, Boog came trotting over to the mound to talk to me. "Hey Jimmy," he said. "Whatever happened to your fastball up and away?" The experiment ended.

He was an underrated first basemen. He had very good hands, was able to pull balls out of the dirt and had tremendous arm span.

On Boog's hitting: He flew under the radar until he had a bat in his hand. He could hit some long, long, long home runs. I remember the home run he hit over the roof in Chicago's Comiskey Park off Juan Pizarro. Then he would come back in the dugout, and we would ask him, "Did you get all of it?" And he would shake his head and say he just didn't quite get it. It became a joke—Boog never hit a home run that he got all of.

His swing had a lot of moving parts, but it was a very functional swing. I can just imagine what he would do if he played in Camden Yards. He hit a home run off me in 1976 when he was on the Indians. Glad to help him out.

He never really had bad years—some just weren't as good as his great years. A down year for Boog was twenty-three home runs.

In the locker room: He had a great sense of humor. In the locker room, if someone said, "Boog, I hear you are a really good cook," everybody else in locker room would say, "Look at the size of him—he must really like what he cooks."

Camaraderie: Part of playing on great teams like the Orioles was the friendship, the camaraderie, the lifelong relationships you have with people.

Players in our era all went through the same thing. There was no arbitration, so you had to hold out, to beg, to cajole them to give you what you thought was fair. Jerry Hoffberger, our owner, was the nicest guy in the world until it came to salary time. So I worked at Hamburger's [department store] selling men's clothing, and they would let me leave early to give speeches, for twenty-five dollars, at Little League banquets. I would get maybe thirty-five dollars if the banquet was out of town. Boog did the same thing. Back then, you made what they told you you were going to make.

I am in the Hall of Fame because of Boog Powell and players like him. So when a teammate is not feeling well [Boog's bout with colon cancer in 1997], you get in your car and you drive down to see him. For me, it is a minuscule show of respect.

On Boog's status in Baltimore: One of the great things about playing for a long period of time—like Boog, Brooks and I all did—is that you get to see who you want to be like. You see that Brooks Robinson is a terrific player on the field and such a nice guy off the field. Then you see other guys and you observe that in the same amount of time it takes to be rude to somebody, you can be pleasant to them. Boog does not have to put on any airs. Boog is Boog. His stature in Baltimore is very high for a number of reasons. He was a good player. He was connected to the past. Now so many people go to Camden Yards. His stand there is a big part of the ballpark experience and allows him to stay connected to the present. Plus, he is a fabulous guy.

FRANK ROBINSON—BOOG'S ORIOLES TEAMMATE, 1966-71; BOOG'S MANAGER IN CLEVELAND, 1975-76

On playing with and managing Boog: As a teammate, you couldn't ask for anyone better. You couldn't keep up with Boog. He would be telling stories, eating and drinking his beer—he went on forever. He was a fun-loving guy, but each day he was ready to go at the ballpark. He gave you all he had, and it was pretty good, day in and day out.

Yeah, I did fine him and Charlie Lau a dollar in our clubhouse kangaroo court for cleaning fish in the shower. All of the court's fines were one dollar. We even fined the owner, Jerry Hoffberger, a dollar. The idea of the kangaroo court was to point out mistakes and poke fun at it while getting the point across. Cleaning fish in the shower was a little much.

As a manager, I wish I had twenty-five players like him. Boog came to the ballpark to play. Once the game started, he knew what to do and how to do it. He enjoyed himself. He enjoyed the game. In the clubhouse, he was no problem. He was a real delight to have on the ball club.

On Boog as a hitter: Boog was a very good hitter, a clutch hitter who could hit the ball to the opposite field. In a tough situation, he was a tough out. He was underrated, but he did get his just do in 1970 when he was MVP. Our Oriole teams had a very solid lineup top to bottom. Boog, Brooks and I moved around in the lineup, batting third, fourth and fifth. We were tough to pitch to. Our approach was that if the pitcher won't give me anything to hit, if he won't throw it over the plate, then drop the bat, go to first and let the guy behind you do his job.

On hitting home runs in Memorial Stadium: Most ballparks give you something and take away something. At Memorial Stadium, the distance down the foul lines was barely three hundred feet. If you hit the ball from the foul lines to the bullpens in left center and right center, you had no problem. But if you started going out toward center field, yeah, you would have problems. You didn't want to try to make a living hitting out there.

On Boog's size: Boog carried his weight differently than most guys his size. He moved around the bases and could score from first on a ball hit in the gap. He was six-foot-four and wasn't what I call "fat." He was nimble around first base and saved a lot of errors from infielders because he was very good at

Band of brothers. Frank Robinson, Eddie Watt, Paul Blair, Vic Roznosky, Russ Snyder and Boog celebrate a 1966 win over the Boston Red Sox. *Reprinted with permission of the Baltimore Sun Media Group. All rights reserved.*

picking a throw off the ground and shifting around the bag. I really didn't see a problem with Boog and his weight. Looking at him, you might say he needs to lose some weight, but I think his weight never interfered with playing the game and performing.

On almost drowning at a team pool party in 1966: Boog did not throw me in the pool. He and some other guys threatened to and wanted to. I had my clothes on and was sitting in a lounge chair. I told them I don't swim. I don't fool around with water. But they insisted. So I said to Boog and the guys, "Okay, let me go in and put on pair of swimming trunks." They said okay.

I changed and came back out and was going to outsmart them by slipping into the pool. But I slipped into the pool thinking I was in the shallow when I was really in the deep end. There were a lot of people around that pool, and I came up three times from the bottom. Each time I hollered, "Help! Help! Help!" The third time I went down, I thought that was it.

I have heard people say that when you are drowning, you see headlines. I did, and that headline said, "Frank Robinson Drowns at Team Party; Bill DeWitt [the Cincinnati owner who traded him to Baltimore] Gets Last Laugh."

All of a sudden, I feel this hand on my arm pulling me toward the surface. But then all of sudden it lets go, and I slide back down to the bottom. I thought, "Wait a minute—he didn't finish the job." Later, I found out the hand belonged to Andy Etchebarren and that he let me go because he had run out of air. He came back and slid me over to the side of the pool. All the time I had told myself, "Don't swallow any water." And when I came out of the pool, I didn't have any water in my lungs.

A little later, I looked at the situation and thought how silly it was for me not to just have crawled over the side of the pool and gotten out. But at the time, I didn't think of it.

On Boog's status in Baltimore: When I saw him at his stand in Camden Yards, I couldn't believe how many people stopped there. People just responded to him. They loved him.

When I was with the Orioles as assistant general manager, my office was in the warehouse right above his stand. At lunchtime, he used to throw me a sandwich up through the warehouse window. He was pretty accurate, too. The sandwiches were outstanding.

He is a fun-loving guy, a fixture in Baltimore. Maybe as a player he didn't get the credit he deserved. But his teammates certainly appreciated what he did for us on and off the field.

BIBLIOGRAPHY

BOOKS

Berney, Louis. *Tales from the Oriole Dugout*. New York: Sports Publishing, 2004.

Bradlee, Ben, Jr. *The Kid: The Immortal Life of Ted Williams*. New York: Little, Brown and Co., 2013.

Eisenberg, John. *From 33rd Street to Camden Yards: An Oral History of the Baltimore Orioles*. Chicago: Contemporary Books, 2001.

Honig, Donald. *The Greatest First Basemen of All Time*. New York: Crown Publishers Inc., 1988.

Loverro, Thom. *The Home of the Game: The Story of Camden Yards*. Taylor Trade Publishing, 1999.

Pahigian, Josh, and Kevin O'Connell. *The Ultimate Baseball Road Trip: A Fan's Guide to Major League Stadiums*. Guilford, CT: Lyons Press, 2004.

Patterson, Ted. *The Baltimore Orioles: Four Decades of Magic from 33rd Street to Camden Yards*. Dallas, TX: Taylor Publishing, 2000.

————. *Day by Day in Orioles History*. New York: Sports Publishing, 1999.

Powell, John "Boog." *Mesquite Cookery*. Dunedin, FL: Marva Daun Publishing, 1986.

Reichler, Joseph L. *The Baseball Encyclopedia, Fourth Edition*. New York: Macmillan Publishing Co., 1979.

Richmond, Peter. *Camden Yards and the Building of an American Dream*. New York: Simon & Schuster, 1993.

Russo, Jim, and Bob Hammel. *Super Scout: Thirty-Five Years of Major League Scouting*. Los Angeles, CA: Bonus Books, 1992.

Thompson, Chuck. *Ain't the Beer Cold!* South Bend, IN: Diamond Communications, 1996.

Whiting, Robert. *The Chrysanthemum and the Bat*. New York: Dodd, Mead and Co., 1977.

MAGAZINES

Newsweek. "Bauer's Birds." July 27, 1964.

Saturday Evening Post. "People on the Way Up: John (Boog) Powell of the Baltimore Orioles." May 5, 1962.

Sports Illustrated. "Always Ready to Chew the Fat." July 16, 1973.

————. "The Ball's Going Pfttt." May 18, 1974.

————. "Boog! The Musical." July 19, 1971.

————. "Brooks, Boog, Frank." November 7, 1966.

———. "Field of Dreams." October 10, 1994.

———. "Flake and Brandt and Big Boog." April 9, 1962.

———. "Getting a Belt Out of Boog." September 1, 1975.

———. "Here Come the Young Turks." July 11, 1966.

———. "In a Strike Zone of His Own." July 26, 1976.

———. "Player of the Week." July 18, 1966.

———. "This Tree Is Safe." July 5, 1971.

NEWSPAPERS

Eisenberg, John. "Bonds that Made '66 O's Special Remain Strong." *Baltimore Sun*, October 21, 2006.

———. "Cancer News Shakes O's Family to Core." *Baltimore Sun*, October 7, 1998.

———. "Fans, O's, Share Tears, Memories." *Baltimore Sun*, October 7, 1991.

———. "Hey, You're Boog Powell!" *Baltimore Sun*, July 15, 1986.

———. "How the Magic Began." *Baltimore Sun*, July 13, 1986.

———. "O's Weaver Was Pioneer of Stats, Game Series." *Baltimore Sun*, August 20, 2004.

———. "20 Years Later, Owners Aren't Reserved about Salaries." *Baltimore Sun*, July 17, 1986.

Klingaman, Mike. "His Meat: Prime Ribbing Boog Powell." *Baltimore Sun*, June 24, 1997.

———. "Transformed Behind Brooks, Frank and Boog, Orioles Swept the Dodgers in '66 Series and Turned Club into a Powerhouse." *Baltimore Sun*, March 30, 2014

PressBox. "Boog Powell: Meat of the Order." May 14, 2003.

Sporting News. "Aroused Boog Awakens from Long Snooze at Bat." October 7, 1972.

———. "Baltimore Foes Get Bad News: Boog's Back and Bat Is Booming." August 21, 1971.

———. "Best of Murray." October 22, 1966.

———. "Best Yet to Come—Slugger Boog." January 16, 1965.

———. "Birds Aflutter on Boog's Batting Boom." March 28, 1970.

———. "Birds Hope 'No-Takers' Shock Will Restore Punch in Powell." January 5, 1974.

———. "Boog Breezes as A.L. MVP." November 21, 1970.

———. "Boog Buoys Birds with Long-Dormant Bat." October 5, 1974.

———. "Boog on Beam as Oriole Blockbuster." August 1, 1964.

———. "Boog Plays Boo Bird Over DH Role." March 10, 1973.

———. "Boog's Beef." May 15, 1995.

———. "Boog's Glue Glove Rates Big Hand from Bird Pals." September 12, 1970.

———. "Boog Still Lives for Laughs." March 13, 1982.

———. "Boog Was a Fielder, Too." July 8, 1985.

———. "Collapse of Oriole Hitters Driving Earl to Distraction." August 19, 1972.

———. "If Boog Ever Has a Really Big Year, Pitchers Beware." March 25, 1967.

———. "It's Back to Campus for Boog…He'll Keep Batting Eye Sharp." November 8, 1969.

———. "Little League Boasts 700 Grads in Pro Ball." April 23, 1966.

———. "No Wonder Boog Is MVP—Avoided Usual Spring Skid." November 28, 1970.

———. "On Second Thought, Boog Now Anxious for Comeback Award." June 15, 1968.

———. "Orioles Past and Present Rekindle Memorial Memories One Last Time." October 14, 1991.

———. "Orioles Tweet-Tweet Time to Heat Beat in Boog's Bat." July 23, 1966.

———. "Powell Seeking Comeback Prize for 'Powhatan' Role." September 6, 1975.

———. "Sonic Boom from Boog's Silent Bat." July 18, 1970.

———. "$10 per Pound Bauer's Penalty for Hefty Boog." August 28, 1965.

———. "Voice of the Fan." September 13, 1975.

ONLINE SOURCES

Baseball-Reference.com. "Career Home Runs." http://www.baseball-reference.com/leaders/HR_career.shtml.

Retrosheet. www.retrosheet.org.

Wancho, Joseph. "Boog Powell." Society for American Baseball Research. http://sabr.org/bioproj/person/54f3c5fa.

ABOUT THE AUTHORS AND THE PHOTOGRAPHER

ROB KASPER

This is the second book Rob Kasper has written for The History Press. The first, *Baltimore Beer: A Satisfying History of Charm City Brewing*, was published in 2011. Prior to writing books, he was a features columnist for the *Baltimore Sun* and during that time wrote several stories about Boog Powell's cooking.

Rob Kasper and Boog Powell.

That experience, plus a lifelong interest in baseball, prompted him to undertake this project.

During his thirty-three years at the *Sun* (1978–2011), Kasper won numerous writing awards and authored a nationally syndicated food column. The Association of Food Journalists cited his 2008 food columns as among the best in comparable American and Canadian newspapers. This marked the fifth time in two decades that his writing had been so honored by the association. He has also won two National Headliner Awards.

A native of Dodge City Kansas, Kasper received his undergraduate degree in American studies from the University of Kansas and an MS in journalism from Northwestern University, graduating with honors and distinction. He was a reporter for the *Hammond (Indiana) Times* and the *Louisville Times* newspapers before joining the *Sun*. He lives with his wife, Judith, a professor in the Johns Hopkins Bloomberg School of Public Health, in a downtown Baltimore row house. They have two sons.

JOHN "BOOG" POWELL

John "Boog" Powell is a former major-league baseball player. During his seventeen seasons in the big leagues, he played for the Baltimore Orioles, the Cleveland Indians and the Los Angeles Dodgers. He debuted in 1961 as an outfielder but soon moved to first base.

He was a four-time All Star, a prominent member of two world champion Orioles teams (1966 and 1970) and was named the American League's MVP in 1970. In addition, he was named Comeback Player of the Year in Baltimore in 1966 and in Cleveland in 1975. Known for his epic home runs, he swatted a total of 339 in his career.

After retiring from baseball in 1977, he owned and operated a marina in Key West, Florida, and appeared as one of the Miller-Lite All Stars in a widely praised series of beer commercials featuring former athletes. In 1992, at the debut of Oriole Park at Camden Yards, he opened Boog's Bar-B-Q, a concept in ballpark concessions that has since been copied around the United States. He appears regularly at the Camden Yards stand, greeting fans, signing autographs and urging the workers to keep the pit beef rare.

He and his wife, Jan, divide their time between homes in Key West and Maryland's Eastern Shore. The Powells have three children: J.W., Jennifer and Jill. This is his second book. His first, *Mesquite Cookery*, was published in 1986.

JIM BURGER

Jim Burger has been a professional photographer in Baltimore since 1982. He learned his craft at the Maryland Institute College of Art, and he learned his trade at the *Baltimore City Paper* and the *Baltimore Sun*. At the *Sun*, he worked

alongside Rob Kasper and collaborated with him on *Baltimore Beer: A Satisfying History of Charm City Brewing*. His work has appeared in the *Philadelphia Inquirer*, the *San Francisco Examiner* and the *Los Angeles Times*. A lifelong baseball fan, he smuggled a transistor radio into his grade school and listened to the 1970 World Series through an earphone. The Baltimore Orioles defeated the Cincinnati Reds in five games.